劉業昭書畫紀念展

A Memorial Exhibition of Liu Yeh-jau's Art

展　期：2005/3/10～4/3
地　點：國立歷史博物館四樓

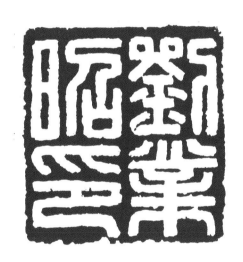

國立歷史博物館
National Museum Of History

目 次 Contents

館 序 Preface　　　　　　　　　　　黃永川　　　　　　　　　　4

專 文 Essays

「劉業昭書畫紀念展」有感　　　　　　楚崧秋　　　　　　　　　　6

春風入座有餘温　　　　　　　　　　　王壽來　　　　　　　　　　7

山水有情留元智　　　　　　　　　　　詹世弘　　　　　　　　　　11

悼念鄉先進劉業昭先生　　　　　　　　程抱南　　　　　　　　　　15

英雄總是布衣多　　　　　　　　　　　李在中　　　　　　　　　　16

送別大師　　　　　　　　　　　　　　黃美珠　　　　　　　　　　18

You Are Never Too Old To Teach　　Christopher Morrison　　19

感恩與感謝/From The Liu Family　　劉氏家屬　　　　　　　　　21

圖 版 Plates　　　　　　　　　　　　　　　　　　　　　　25

素描・畫稿 drawings・sketches　　　　　　　　　　　　　113

年表 Chronological Biography　　　　　　　　　　　　125

附錄 Appendix　　　　　　　　　　　　　　　　　　　131
The Art of Living　　　　　　　　Sam Whiting
Leading the Way/開風氣之先
—Asian American Artists of the Older Generation　Irene Poon 潘朵姬
　　James Yeh-jau Liu Exhibition History

序

　　劉業昭先生，字左彝，湖南長沙人，生於民前一年（一九一〇年），杭州藝專畢業後，赴日本帝國美術學校暨日本明治大學研究。抗日戰爭時，參加抗戰行列；政府遷台後奉派為東南行政長官公署政務委員會文化教育處處長、交通部總務司長等職，並任教於國立台灣藝專，二〇〇三年在美國加州馬林郡(Marin)去世，享壽九十三歲。

　　劉氏為書香世家，有深厚的國學基礎，在杭州藝專時受教於林風眠、潘天壽大師，筆墨融合中西技法，作品呈多樣表現，所繪山水、人物、花卉、翎毛走獸，皆具特色；山水蒼秀沈鬱，水墨淋漓，人物筆墨酣沈，渾厚和諧。花卉著色濃郁，技法獨特，早年尤以墨梅著稱。一九六七年劉業昭先生移居美國，並在舊金山的堤波隴鎮(Tiburon)成立「寒溪畫室」，結識許多愛好藝術的中外友人，平日作畫之餘，對世局及社會脈動仍十分關切，並積極參與社區公益活動。一九九三年美國政府以中國十二生肖發行郵票，劉業昭先生開始為首日封配畫，廣受集郵者及愛好書畫藝術人士喜愛，並持續了十年，成功的促進中華文化傳播。

　　本館為推崇這位一生忠貞愛國、熱愛家庭及朋友、藝事造詣深厚的大師。特定於二〇〇五年三月十日至四月三日假國立歷史博物館四樓舉辦「劉業昭書畫紀念展」，由劉氏家屬提供書畫作品、遺物、手稿、生肖首日封、照片等約百餘件，其中包括一些小品及小斗方畫作，殊為珍貴。睹物思人，藉本展表達追思懷念之忱。

國立歷史博物館
代理館長

Preface

Mr. Liu Yeh-jau was born in Changsha City, Hunan Province in 1910. After graduating from the College of Art in Hangzhou, he enrolled in the Imperial Art Academy in Tokyo and Meiji University. During the Sino-Japanese War, he joined the army. Later, after the government moved to Taiwan, he was appointed to be the head of the Cultural and Educational Department of the Government Administration Council, director of the General Affairs Department of the Ministry of Communications, and later, a teacher at the National Taiwan Art Institute. In 2003, he died in California, U.S.A. at the age of 93.

Mr. Liu came from a literary family and was well educated in the Chinese classics. During his college period in Hangzhou, he learned Western and traditional Chinese art skills from two masters, Lin Feng-mien and Pan Tien-shou. He integrated both skills to present a variety of expressions in his works. Gradually, he developed a personal style. He revealed a sense of depth by his unrestrained use of ink in his landscape paintings. The figures he created in his works are harmonious, and the flowers are presented with heavy colors and unique skills. He was also famous for ink plum paintings in his early years. In 1976, Mr. Liu moved to America, established the "Han Syi Studio" in San Francisco and knew many Chinese and foreign friends who loved art. At the same time, he was deeply concerned with social development and participated enthusiastically in community public service activities. In addition, when the US government published stamps with the design of the Twelve Chinese Animal Signs in 1993, Mr. Liu was invited to illustrate the first day covers, which were very popular. He had worked as an illustrator for ten years and successfully promoted cultural exchanges.

"A Memorial Exhibition of Liu Yeh-jan's Art" is to be held from March 10th to April 3rd, 2005 to honor Mr. Liu's strong passion for his country, families and friends, as well as his great artistic achievements. For this exhibition, more than one hundred pieces of Mr. Liu's valuable paintings, calligraphies, relics, manuscripts, first day cover illustrations and photographs have been provided by his family.

Huang, Yuan-Chung

Acting Director

National Museum of History

「劉業昭書畫紀念展」有感

楚崧秋

　　與三湘名士劉業昭左彝兄相交近一甲子，其為人向重道義，彼此心性投合，每能互言所短，而情義益進，是誠人生樂事，彌足珍貴。

　　近四十年間，劉兄勘破世間百事，專注丹青，以遂其素志，乃能成不朽之業，為眾譽稱一代名師，足見人生進退取捨為用大矣。

　　個人於繪業所知膚淺，惟酷愛之，以其可以怡情養性，廣見博識，馴至結緣締交，共進於另一世界。近代方家自張大千居士以還，每相交往，有心契神馳之義，而左彝兄則為余此道中之莫逆。

　　今其哲嗣與玳賢阮等，善體父志，克盡孝思，年來廣事搜蒐，總擇精作，承台北歷史博物館玉成，舉行「劉業昭書畫紀念展」三閱月，以期呈獻社會，供諸共賞。余既感左彝志業形影，歷歷在目，復以其後嗣與友朋至誠相促，深願略抒哀悃，同伸雅祝，至其畫業工力，則俟之百世公評可矣。

（作者為中國新聞學會榮譽會長）

中華民國九十四年正月之吉

春風入座有餘溫

王壽來

　　友人從舊金山打長途電話報訊，高齡九十四歲的老畫家劉業昭老師出了車禍，傷勢嚴重，在醫院裡與死神拔河十數日，終告不支。他卜居的小鎮，決定以「生命的慶典」（A Celebration of Life）為名舉行追思會，禮讚他不斷發光發熱的精彩人生。

　　猶記十餘年前，我被行政院新聞局外派到舊金山，出任新聞處主任不久，有一天，駐地辦事處的茅承祖顧問跟我聊到灣區的藝文界人士，他如數家珍地簡介每個人不凡的成就，令我印象最深的，是舊金山大橋的北邊有個叫堤波隆（Tiburon）的小鎮，資深畫家劉業昭老師在那兒開了個「寒溪畫室」，店外一年到頭都掛著青天白日國旗，不僅贏得當地人士發自內心的尊敬，也成為小鎮主街上的地標，很值得前往拜訪一下。

　　在茅氏的熱心安排下，我終於跟劉老師碰了面，雖然兩人年齡相差近四十歲，而我們一見如故、相見恨晚。我倆能成為忘年之交的關鍵因素，就是劉老師有著典型湖南人的脾氣，只要遇著對味的人，即使大家是初次見面，他也會毫無顧慮的，掏心掏肺地道盡心中的塊壘。我們那天會面就是這樣的情形。

　　我還記得，時節已是深秋，習習的海風透著些許寒意，茅顧問、劉老師與我三人，在畫廊對街蛋糕店的露台，面對著如詩如畫的海天美景，一邊品啜香醇的咖啡，一邊天南地北的話家常。劉老師的談興甚濃，打開話匣子後，娓娓道來當年他是如何進入杭州美專，追隨林風眠、潘天壽等大師學了六年美術；抗戰軍興，他毅然投筆報效黨國；後來備受賞識，一度擔任湖南省黨部副主委；政府遷台袁守謙先生主政交通部，他出任總務司長，運籌帷幄；袁氏去職後，他重拾繪畫舊業，應聘到國立藝專執教；他怎樣與鄭月波與王昌杰兩畫家以「三劍客」之姿，聯袂來舊金山開闢人生第二春，以及在加州舊金山大學藝術學院教畫退休後，如何看中堤波隆這塊依山傍海、與舊金山大橋遙遙相望的洞天福地，下決心後半輩子靠一支彩筆為生的曲折經過。

　　長久以來，我一直很喜歡美國作家海明威的作品，衷心服膺他在《老人與海》中所說「男子漢可被毀滅，不可被擊敗」那種奮鬥不懈、愈挫愈勇的氣魄。對海氏親自下場鬥牛、赴非洲打獵、到墨西哥

灣海釣、數度充當戰地記者等等充滿冒險與刺激的生命跨度，更是佩服得無以復加。跟海明威相比，劉老師高潮迭起、人生舞台不斷作大幅度轉換的豐富閱歷，其生命的活力又豈遑多讓！

按理說，以其年登耄耋之年，且已遠離台灣是是非非的政治圈，對世事早可不加聞問，但他始終抱持傳統中國知識份子「以天下為己任」的胸懷，時時刻刻關心著國事、天下事。他關心美國總統的選舉，也同樣關心台灣的總統選舉，對台北日益劇烈的政情變化，更是憂心忡忡；他熱心參加雙十國慶酒會、升旗典禮、灣區的藝文與公益活動，也不放棄堤波隆的扶輪社、遊艇俱樂部。只要能說得出名堂，捐錢從不落人於後，捐畫更是小事一樁。

華人在美國住久了，不少人都有滿腹的理財經，至少在量入為出、節儉至上的策略下，也多能混得身有餘裕，無後顧之憂。劉老師的畫作一直很有銷路，惟二三十年打拼下來，依然兩袖清風，家無恆產。他前後三次回台灣舉行畫展，每次少說亦有數萬美金的進帳，經濟方面卻仍感捉襟見肘。講起這些生活困境，他總會無奈地說：「沒辦法，個性使然，我知道我的手太鬆了！」

他當然有自知之明，但在他的眼中，只有大我，只有朋友，其他一切事只能靠邊站、往後擠。

劉老師仰賴賣畫為生，畫廊生意的好壞影響生計，他當然關心，然而，對一名藝術家而言，作品能賣，固然重要，更重要的卻是，如何能在創作的道路上精進不輟，走出自己的面目與風格，甚至能成「一家之言」，以自己匠心獨運的視覺語彙，引領一代藝術風潮。

過去我在灣區工作時，要是單獨去堤波隆探望老師，每每他會指著牆上的近作，面帶期盼的神色說：「壽來兄，千萬不要客氣啊！請你仔細瞧瞧，我的畫究竟有沒有一點進步？」他不加官銜，也不直乎名字，逕以「兄」相稱，且希望我這個後生晚輩能直言無隱地提供一些意見，老一輩人的謙虛與氣度，真讓人不得不打心裡折服！

有一次他要我點題，作為山水的題材，我未多加思索，信口建議說，張繼的《楓橋夜泊》可是千古傳誦的名篇，何不拿其最後一句「夜半鐘聲到客船」造景，以崇山峻嶺為主畫面，點染一山寺掩映其中，下方添增一葉緩緩駛入的蘭舟，落款時再題上原詩，如此必能引發共鳴，贏得有緣人的青睞。

此議劉老師認為妙極，欣然照辦。畫成之後，招我專程前往欣賞，果然情味深厚，把遊子異鄉羈旅，空山晚鐘迴盪的孤寂，刻劃得淋漓盡致，也再度驗證了老師被外界譽為丹青妙手，並非浪得虛名。

新畫在店裡甫一掛出，就被識者捷足先登，善價購去，劉老師喜獲知音之餘，乃依同一主題又畫了一張，跟其他數十幅作品一起帶到台灣展出。他的美籍好友布萊恩，義薄雲天，竟請假陪他遠征台北，協助佈展、撤展、看守展場等，照顧得無微不至，讓老師在舊金山的眾親友大為放心。記得，他在回台灣的短短半個多月中，還從台北打過好幾次電話給我，劈頭第一句話照例是：「壽來兄，我是業昭啊！」今後，天上人間，那親切、爽朗、帶著湖南鄉音味道的國語，又何處得以再聞？

　　那次劉老師在台北展畫，相當成功，展出期間每日都有斬獲，最後又出現一位大手筆的收藏家，一口氣把所剩的畫全部買下。事後，我們坐在堤波隆同一家店裡享受著咖啡，劉老師面露幾分得意，笑眯眯地跟我講：「我帶去的畫最後全讓給了一個人，但在旅館裡我還私藏了一幅，沒捨得拿出來，你也許猜得著，就是那張你最喜歡的夜半鐘聲，我特地留下來要送給你當紀念！」

　　老人家情深義重，做人何其週到！我輩縱欲投桃報李，又能用什麼來報答他的厚愛於萬一呢？

　　個人調回台北服務匆匆已六年多，因公因私也常回舊金山，好幾次下飛機第一件事，就是直奔堤波隆「寒溪畫室」看劉老師，而他見到我遠道而來，總是開心得闔不攏嘴，每一次他都會像獻寶似的，把尚未送裱的畫一一鋪在地上，展示他的創作成績。「我們爺兒倆」旁若無人、有說有笑地蹲著看畫的情景，讓瞥見這一幕的朋友無不暗自心羨，也讓剛好上門的顧客受到冷落，甚至有點兒不知所措。

　　每一回聚首，我們都是在堤波隆最道地的中餐館「怡園」用過晚餐，才興盡賦別。餐館主人車先生多年來一直是老師的畫迷，也是一位很有俠情義氣的性情中人，經常奉送美酒招待。有那麼一兩回，他還慨然堅持作東，不收分文。劉老師為人平易，交遊廣闊，所到之處，惠及友朋，此為一例。

　　儘管公務繁忙，我回台北工作後，還是三不五時地拿起話筒問候劉老師及師母，在電話那一端，他經常會問：「你何時才能抽空再來舊金山呢？你一定要過來給我一點指教，看看我的畫有沒有什麼突破？」

　　人們大概很難想像，一個九十多歲的老畫家，猶能像無懼千里風沙的取經者，滿懷雄心壯志。他日夜揮毫，念茲在茲的，仍在於不斷自我超越，為藝術生命奮力尋求定位。拿近代國畫大師齊白石、張大千在六、七十歲時之「衰年變法」比較，劉老師晚年爐火純青、獨樹

一幀的大筆「渲擴」，益發顯得難能可貴。

劉老師曾被選為堤波隆的風雲人物，房東為示對他的尊敬，無視市場行情，一二十年來從不漲租。美西重量級媒體「舊金山紀事報」前不久亦作專題報導，推崇他的藝術成就與傑出貢獻。老師畫作的知音，遍佈於全美各地，其中自然有不少是僑界友人，但光顧其畫廊的美籍人士，似乎更多。堤波隆的首富摩瑞遜先生在世時，就收藏有百餘幅劉老師的代表作，兩人因而成為至交，摩氏的兒子克瑞斯拜劉老師學畫，事師如父，常能就近之便，克盡「有事弟子服其勞」的義務。兩代畫緣，傳為美談。

劉老師的尊翁，是湖南有名的書法家，家學淵源，他的行草筆走龍蛇，蒼勁挺拔，落款時，多題寫詩詞。畫山水，常題「我有故山常自寫」、「遠望家山」；寫墨梅，輒題「故山風雪深寒夜，唯有梅花獨自香」，在在顯示他內心深處對故國家園的深深懷念。從當年避秦來台，到落腳灣區長期定居，數十寒暑已在不知不覺中悄然流逝。在現實生活上，他的確睽違家鄉已久，可是，在書畫的天地裡，他始終駐守著一方淨土，那一直是他的精神家園，從未離開過一天。

若將人生比喻成一幅畫，那麼，劉老師終於畫完這幅精心之作的最後一筆。他的封筆辭世，對他來說，或許像落花無言，並無太多掙扎及遺憾，但對深愛著他的親人與朋友，以及對無數喜歡其畫作的人們而言，心中卻糾結著幾多失落與不捨。

我跟女兒說：「這幾天我有可能夢見劉爺爺，因為他一向是個多禮的人，這回要去那麼遠的地方，一定會來跟我道別！」果能如此，雖說魂夢無憑，亦遠勝過從此幽明永隔吧！

春風已去，餘溫猶在。堤波隆的主街上，今後再也見不到終年掛著中華民國國旗的「寒溪畫室」主人身影，但我們這些認識劉老師的人，將帶著這份餘溫、這份悠悠不盡的懷念，繼續趕路……

（作者為行政院文化建設委員會參事）

山水有情留元智

詹世弘

　　說起與劉業昭先生的一段因緣，卻要從他去世以後說起，讓我這個大半生從事工程科學的人，覺得人與人之間的交遊往來，無分死生契闊，冥冥中自有定數與安排。否則劉先生與我同時在美國三十年，他在加州作畫、我在威州教書，其間無緣相見，卻因他的一本畫冊激起我前往拜訪購畫的一念，沒想到這一念終究晚了一步，劉先生已然與世長辭。究竟我與劉先生是有緣無份，還是他自己揀選了元智，來作為他的部份作品最後典藏之所，因而約我來見呢？我寧可相信是後者。

　　1999年，元智大學以校長之職相邀，我在恩師田長霖先生的支持下，應聘回國任職。元智成立至今雖然才十五年，但已打下堅實的基礎，得到外界之肯定。我也時常思考除了「綠色科技」與「E化校園」的主軸之外，元智要實踐開創未來，超越自我、追求卓越的目標，也要注重國際化與人文精神的培養。

　　元智以理工起家，但人文是一切知識的基礎，因此在設校之時即已就成立一所全方位的大學預作規劃。這個理想在1997年元智升格成為大學後實現，人文社會研究學院相關系所陸續成立，加上原已設立的元智藝術中心，這方面起步雖晚，但表現卻是可圈可點，學校也頗以此自豪。我也希望在此方面繼續加強，讓元智成為科技與人文並重的大學。

　　而在國際化方面，我也與各系所主管奔波於美國與世界各地，希望為元智尋找適當的國際夥伴，使元智邁向世界化、國際化的道路。因此因緣際會結識當時教育部派駐在舊金山的代表---駐舊金山文化組組長黃美珠女士，也承她多所協助，牽成元智與美國一些大學的合作。黃女士堪稱是熱心專業的外交人員，每次路過舊金山，只要她有空，必定前來相迎，看看有什麼需要幫忙之處，也讓我感受到一點教育部對私立大學的眷顧。

　　黃組長是劉先生的忘年好友，言談中常聽她提起劉先生這位在蒂伯倫(Tiburon)社區中普受外國友人尊重的桂冠藝術家，我可以感受到她對這位前輩畫家不只是推崇他的藝術造詣以及心懷家國的情操，更有一種執弟子之禮的敬重。只是我身處旅次，行程緊促，實在無暇顧及其他。

及至某次我提起往訪國外大學，到底該帶什麼代表性的禮物時，黃組長也才提起有時她的辦公室也為此傷透腦筋，有時碰到重要場合須送禮，而辦公室又無足夠經費，只要向劉先生開口，他一定會以半買半送甚至義助的方式提供畫作，這樣的禮物送給學術界朋友非常合適。她順手拿了一本劉先生的畫冊給我，記得她還鄭重交代：劉先生作畫基礎工夫深厚，又能兼融中西，其畫作在市場上頗受歡迎，但對朋友總是折價相讓；而他高齡逾九十仍開設畫室以求獨立生活，精神可嘉，千萬不可濫用此項特權等等。就因如此，劉先生的一本畫冊--「劉業昭八十回顧展畫集」便收在我的行囊之中攜回台灣，打算日後細細觀賞。

　　沒想到回國之後，校務及教學兩忙，我又身兼其他數項職務，畫冊便被我置入書架，這一擱就擱了許久。二年之後的某一日，我忽然心血來潮，從書架上取下劉先生的畫冊來觀賞，我對藝術本是門外漢，但劉先生流暢自然的作畫風格使他的畫作彷彿注入真實的生命，我只覺得那些畫散發出一種躍動的力量，深深吸引住我。我及內人尤其喜愛其中一幅枝頭群鳥的簡筆畫，簡單幾筆勾勒，就抓住了鳥兒的神韻，我們彷彿聽得到群鳥在枝頭上快樂地嘈雜，心情也跟著愉悅了起來。當下我便決定下次的美國之行一定要抽空前往拜會這位藝術界的高人，請他為我再畫一幅群鳥圖。當時我渾然不知我與劉先生已是天人遙隔了。

　　訪美行程決定之後，我馬上發了一封電郵給黃組長，說明我此行路過舊金山，想要順道往訪劉先生並購畫，請她代為引見等語。黃組長的回覆馬上過來了，她的信只有寥寥幾句，卻有如電影情節般不真實，讓我錯愕不已。信上說：「你應該早點來的，我才剛參加劉大師的追思會。請給我電話。」我們遂又通了電話，原來時日已久，黃組長早已忘了贈我畫冊之事，她從未聽我提起過劉先生，卻選在這時說要前去拜訪，覺得不可思議。我們在電話中商量後，決定仍舊到蒂伯倫走一趟。黃組長的想法是：雖然劉先生已仙逝，但畫室仍在，劉家的小女兒劉興玳女士也仍在整理父親留下來的畫稿，我雖然無緣親炙大師風采，但對心儀的畫家居住作畫之地作最後的瞻仰，也算是一番敬意。同時她也提到：這些畫整理後將均分給四位子女，劉女士為方便隨時照顧父親，與父親住得最近，也最能揣摸父親心意。劉女士深知父親臨終未交代任何遺言，是因為不想為子女添麻煩，但父親一生心繫家國，必然希望畫作歸屬台灣，她也有心完成父親這項心願。

　　黃組長也表示：劉先生生前兩度回國開畫展都在國立歷史博物

館，如果要舉行紀念展，應該還是史博館最適合，史博館也會在展後收藏幾幅畫作；而如果要再另覓一典藏處所，由於劉先生早年曾在「國立台灣藝術大學」的前身「國立藝專」任教，她會建議劉女士先往「國立台灣藝術大學」看看學校的意願，以及是否有合適的典藏之所。其他的就隨緣了。我這時不由不相信是劉先生召喚我而來，注重人文的元智大學收藏劉先生畫作的意願自是無庸置疑，而元智的新大樓正陸續興建規劃當中，找一個理想的典藏處所應不是難事，我遂決定無論如何一定要走這一趟。而這一趟，真的讓我親身體驗了命運的巧妙安排。

見到劉女士，兩人相談甚歡，她帶我參觀了劉先生生前開設的「寒溪畫室」，只見畫室裡到處都是劉先生的畫稿，有的隨興幾筆，也處處都見真意。牆上也掛滿了關於劉先生的剪報，只是睹物思人，不免又是一陣唱嘆。我提起原想請畫家再繪一幅枝頭群鳥圖，沒想到這個願望已經不可能實現。劉女士見我甚為失望，便提議道：「爸爸生前曾就相同主題繪製數幅，校長既然專程來了，就找找看吧！」兩人便抱著姑且一試的心理在畫室裡尋了一遍，卻一無所穫。正要離去的當時，另一樁奇妙的事情發生了，我們忽然瞥見畫室一隅還有幾幅捲軸放在那裡，居然我念念不忘的枝頭群鳥圖就在其中，我大喜過望之餘，深信是九泉之下的劉先生仍如生前一樣殷勤待客，完成了這個晚到客人的心願。劉女士也表示：「爸爸這番指引，也是畫贈有緣人的意思。」遂慨然以畫相贈，我也就恭敬不如從命了。

之後劉女士也說，他要以老畫家生前待客之道來招待我。我們來到了劉先生經常招待朋友的小咖啡館，店裡還貼著他喝咖啡的照片，我終於知道劉先生不只是以畫，他還以充沛的活力與熱忱來為生命的畫布著色，也擄獲了蒂伯崙居民的心。我們之後又去乘坐劉大師經常前往舊金山之渡輪，飽覽蒂伯崙的湖光山色之餘，也有如一場尋訪劉大師之旅。劉女士說就是這樣美麗的景色留住了老畫家，也成為他畫中最常出現的題材。我們在渡輪上閒聊起來，居然又發現原來劉女士的高中最要好同學，就是我的妻妹。內人也曾經提起過他們是同學，這才恍然大悟：原來我們早已有緣目睹劉先生的畫作，妻妹家正廳上懸掛的蔬果圖正是出自畫家之筆。

這時我已下定決心，於是向劉女士提出希望在元智成立劉先生書畫紀念中心的構想。劉女士也表示她也希望為父親的作品尋找一個永久典藏之處，但這是件大事，她不便貿然答應。必須與其他家人商量，同時也會專程回國實地看一下包括元智以及其他可能的地點。我

也表示理解。

　　劉女士的確是體恤父親心意的女兒，她很快便放下一切飛來台灣，除了與國立歷史博物館敲定「劉業昭書畫紀念展」的相關事宜外，也到國立台灣藝術大學及元智本校來勘查適當的典藏處所。劉女士抵達本校時適值十一月十二日國父誕辰紀念日。平常這樣的紀念日學校是不懸掛國旗的，但是那天學校社團忽然決定掛滿國旗，校園一片旗海飄揚，我對劉女士說，這好像是感應到劉先生卅五年來一直在畫室門口掛著國旗一樣。我帶她參觀校園及新落成的元智六館以及正要擴建的圖書館。經過一番溝通，大家都認為在新擴建的圖書館規劃「劉先生書畫紀念中心」頗為理想，能讓年輕學子們更有機會觀賞到劉先生的作品。也剛巧有心收藏劉先生作品的國立台灣藝術大學卻沒有適當空間，只好讓賢。這事有了初步的結論，我的心情大致底定，也算是為與劉先生的一段晚來的因緣略盡了一點棉薄之力。

　　現在「「劉業昭書畫紀念展」即將在國立歷史博物館展出，對大師文采多姿的一生作最後的敬禮，同時也讓大師的部份畫作歸根落葉台灣，相信是符合大師心意的。蒂伯侖山水因大師而更靈秀俊美，我也希望這次的紀念展也為台灣帶來一股清流靈氣。謹以此文聊表我對劉先生的敬意。

（作者為元智大學校長）

　　　　　　　詹世弘寫於「劉業昭書畫紀念展」展出前夕

悼念鄉先進劉業昭先生

程抱南

調融團黨績彌珍，　點染山川筆有神，
更予人間留典範，　無憂無欲樂清貧。

待人爽直兼親切，　談笑常能解百憂，
老去尤耽同眾樂，　咖啡對飲傲王侯。

軒窗百海風帆滿，　盡入「寒溪」畫本中，
世變紛紜心益定，　國旗揚處見精忠！

海角栖遲究可哀，　魂兮何日賦歸來？
楚山楚水澄清後，　好向江城畫落梅。

後學程抱南　二〇〇三年八月於美國華州美瑟島

英雄總是布衣多

李在中

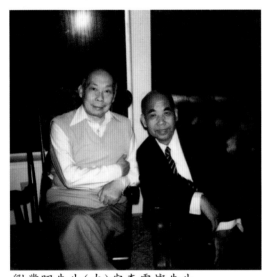

劉業昭先生(左)與李霖燦先生
在舊金山合影

因為劉業昭伯伯與我父親是同窗，又是至交，因此劉伯伯女公子興玎女士和我可以說是有著兩代世誼的情份。在劉伯伯去世以後，興玎跟我談起想要為她父親在臺北歷史博物館舉辦一個紀念畫展時，我覺得這不但是應該做的事，並且還是必須做的一件事。在多次交換意見的談話中，我深入的了解到興玎想辦這個展覽，除了一片摯心以外，更為重要的是她覺得一位熱愛中國繪畫的工作者，幾十年來在異域孤軍奮戰，為發揚中國繪畫而執著不懈的心志，不應該為後人所不知。

由於女兒在舊金山上學的關係，因此每年總會去灣區探望，也必定前往堤埠看望劉伯伯。「寒溪畫室」就在堤埠中心的一條小街上，門面並不很大，但是從櫥窗望進去，各式尺寸及不同題材的國畫，掛在四周的牆面上，條幅並陳，琳瑯滿目。在寧靜的小街道上顯得非常的突出而意味無窮。很能從這些牆面的畫中看出作畫者深厚的觀察力與天人合一的思想性。劉伯伯爽朗又健談，大部分的時間我們的話題都圍繞在他的繪畫上，有一次談到一對來自波士頓的夫婦來買畫的事；這對夫婦買下了一幅以「南瓜」為題材的大畫，用來佈置他們的新居。離開之前，請教劉伯伯這幅畫的中文名稱該怎麼發音才正確，劉伯伯說就叫做「瓜」吧！兩個月以後，這對夫婦又回來了，又買了一些畫，並且對劉伯伯說：你上次告訴我們那幅畫唸成瓜不對，來我們家的朋友們，一看到這幅畫大家都說哇！現在我們已經把這幅畫改名稱為「哇」了。我笑說：反正洋人不講理，隨他們去吧！但是這也表示藝事無國界，四海有知音啊！

在寒溪畫室裡，堆滿了畫稿文件，報章信函，幾乎難有走動的空間。在畫室的另一角落裡，還堆滿了裱畫用的壓克力、鋁框等材料。劉伯伯看出了我的好奇，笑著對我說：「我的畫都是自己親手裱糊裝框的，我每天清早起來高高興興的畫畫，然後來到畫室裡開始一天的活動。一切大小事，我都自己打理，數十年如一日，這是習慣，也是生活的樂趣。跟你講一個小故事啊，有一個人養了一隻小豬做寵物，

每天晚上都要抱著小豬上樓。小豬一天天長大了，重量也一天天增加了。但是因為每晚都抱小豬上樓，卻也感覺不出有什麼多大的不同。可是有那麼一次，這個人因為有事要外出半個月，回來以後，卻再也抱不動這隻小豬了。可見習慣就是堅持而產生的結果，而堅持是有著很大的力量的。」這個小故事讓我無語了一陣子，我自幼生長在一個文史氣氛濃厚的家庭，有幸見到許多上一代藝術文教界的宗師泰斗級的長輩，他們的學識風範自不在話下，但是劉伯伯的這個小豬故事，卻讓我意會到上一代長者們的共同的特點就是，從一而終。不但堅持做一件事，而且做的是虎虎生風，興高彩烈。既不知今夕何夕，也不知老之將至。當天我在開車回舊金山的路上，終於了解到孔老夫子說的：「知之者不如好之者，好之者不如樂之者。」「其為人也，發憤忘食，樂以忘憂，不知老之將至云爾。」這兩句話的真正意思是什麼。

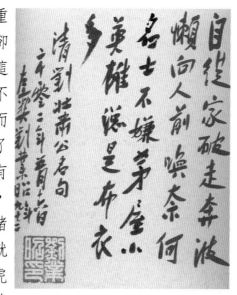

　　二零零二年八月間，在跟劉伯伯告辭前，劉伯伯說：「在中，最近讀劉銘傳先生的詩，特別有體會，寫一首壯肅公的詩送你，我被這首詩感動的無以復加，我來唸給你聽啊：『自從家破走奔波，懶向人前喚奈何；名士不嫌茅屋小，英雄總是布衣多。』

　　興玖要為她父親辦這個紀念畫展是一件極為有意義的事，我想除了能讓大家認識劉伯伯的融圓醇厚的畫藝外，更為重要的一件事情應該是，讓我們透過繪畫的介面看到了一位淡泊名利，為自己的信仰堅持不懈的老畫家的赤子之心。古往今來，在歷史的長河裏，每位留名青史為後世推崇的偉大藝術家，莫不都具有這種共同熱愛生活、樂以忘憂、大愛無私、不為人世間浮雲名利所羈繫的胸懷。我想除了畫布上的映像以外，這才是大藝術家真正想讓我們看到的作品。

（作者為李霖燦教授次子）

　　　　　　　　　　在中　九十三年冬　俄州

送別大師

黃美珠

不相信你走了
門前大國旗依然隨風飛揚
你隨時都會來開門
把「寒溪畫室」的招牌擦亮

開畫室有如姜太公釣魚
你也不以為意
兀自把快樂傳遍蒂柏倫小鎮
一聲聲「嗨！Jimmy」熱情有勁
Happy man! 蒂柏倫傳奇
你已賺得全鎮居民友誼

有客來訪　你歡喜招待
門口的紙鐘撥弄一下
暫時打烊　咱們去喝咖啡
儘管天南地北　從抗戰說起
如果時間不夠　再回去撥鐘

這次紙鐘失去了指引的方向
你去了哪裡？
是拎著那個小布袋進城訪友嗎？
還是躲到哪裡去喝咖啡了？
我們找不到你……

（作者為前駐舊金山辦事處文化組組長）

"You Are Never Too Old To Teach"

Christopher Morrison

Professor Liu mastered a technique in which he would load several colors onto his brush and by a twisthere, or a turn there would express blends of those colors onto his paper, creating magical landscapes,grapes dancing upon the breeze or the intensity of poets discussing their art. Beyond his painting style,this technique provides a fitting analogy of his character. Constantly a gentle and generous person, one sometimes would be surprised by the directions he took during his lifetime.

I have had the privilege of knowing Professor Liu as mentor, friend, adopted family member and the honor of being his student of most longevity. Having met Professor Liu in 1969, I watched, enthralled, as my father, Keith, bought a beautiful landscape of the Hunan Mountains that the professor had recently painted.Thus began an incredible association and the first of many additions to my father's collection. Over the years our friendship grew, and along with our involvement with Rotary International the bonds between us strengthened. When Keith was diagnosed with cancer and heart disease, Professor Liu was often at hisside, bringing vital Chinese style soups or his own brand of good cheer.

Through out his career in Tiburon, Professor Liu enjoyed reaching out to the community. He often donated paintings for worthy causes and took great pride in demonstrating his art at schools, senior centers and cultural groups in the San Francisco Bay Area. At age 92 Professor Liu was declared Artist Laureate ofTiburon and was still involved with art presentations at our local school through the Rotary club. Now hanging on a wall at one of the schools is a photograph of Professor Liu and twenty eleven and twelve year old art students. Inscribed below the art are the words, "You are never too young to learn -You are never too old to teach".

Over the years Prof. Liu produced thousands of original works of art that people took into their homes, each one containing his passion for life and love of nature. He often took great pride in the fact that his work traveled over the entire world, and kept a large map in his gallery, placing a pin for each location his work would find a home. Pink pins represented private buyers; blue pins indicated museum and corporate purchases. Eventually the map was set aside for lack of room for

any more pins.

One day in July of 1997, I said to him what great satisfaction it must be for him to be one of America's most prolific painters of original art, and how much happiness he has brought to people around the world. His reply was to change my life forever. "I will teach you", he said and for the next six years I would go to his studio, several times a week, to study. Having been an amateur photographer for over 40 years I felt I knew how to capture art, but not how to create it. He showed me how to transfer an image to paper from my imagination, instead of memory, or looking at another image and copying it. He would tell me, "You have your own style", although at the time I couldn't imagine what that could be. After

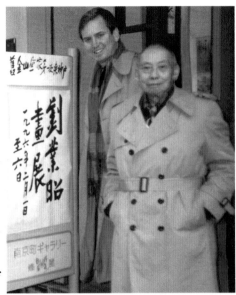

劉業昭1996年2月在日本神戶個展，
與作者合影

some time, with his patience and guidance, I was able to develop my own style, not only in painting but his words have guided my life-path as well.

Professor Liu's "people skills" were of legend. He priced his work fairly so that most people could enjoy it at home, in one form or another. His clients often recall his gentility and friendliness, but should someone try to take advantage of him he would often walk away, refusing to sell to them altogether. One day a young boy of about eight years old came into the gallery looking for a gift for his mother's birthday. I watched from my student table as the boy picked out a painting that he liked. Prof. Liu asked him how much money he had saved to buy a present for his mother; the reply was a meager amount, so far below the asking price that it was beyond consideration. The next thing I saw was the young man walking out the door with the painting under his arm. Later, Professor Liu said to me, "That boy's mother will cherish that painting and the memory of her son for the rest of her life".

Many people have asked me how Professor Liu could be so active and happy in his later life, my reply was always, " His candle burns bright ". After viewing this exhibit, in Taipei, I think you will agree with me that hiscandle burns bright still.

I will remember the kind gentleman who taught me so much about the real meaning of art for the restof my life.

（作者為劉業昭學生）

感恩與感謝

　　今天是一個重要的日子，我們在國立歷史博物館的支持下，以感恩與感謝的心情，帶著父親的作品，回到他念茲在茲的台灣，為我們的父親—劉業昭先生舉辦「劉業昭書畫紀念展」，為他一生對藝事的堅持，作一個最後的見證與紀錄。父親以九十三高齡，於2003年7月棄世，未能親眼見到這個展覽，但我們一路走來，感覺父親也伴隨著我們，我們相信他已經看到了我們所作的一切，他應當是喜悅而欣慰的。

　　四十多年前，父親為了能繼續悠遊於書畫世界，捨棄了官場繁華。一個偶然的機緣，他應聘來美，並且愛上了舊金山附近鐵路小鎮—堤波隴(Tiburon)的美麗山水，因而落腳斯土近四十年，並且在當地開設了「寒溪畫室」。他每天作畫不輟，大筆在畫布上揭染出舊金山灣及金門大橋的美麗身影，他也參與扶輪社，熱心參與當地社區的事務。這種樂觀投入、積極勤勉的生活態度像磁鐵一樣吸引著鎮上的居民與外來的觀光客。小鎮居民從這個來自神秘國度的藝術家身上印證了中國人樂天好客的生活藝術，也從他不可思議的畫筆上見識到偉大的中國文化藝術。漸漸地，父親與他的"寒溪畫室"成為堤波隴小鎮不可或缺的一部份，在他們心目中Jimmy是自己人，是扶輪社的榮譽會員、是堤波隴市的榮譽市民、是有權選美國總統的美國人。Jimmy的藝術成就是他們的驕傲，也因此，堤波隴市在2001年頒給父親桂冠藝術家的殊榮。

　　除了書畫之外，父親高齡卻又健朗，也是大家急欲向他求索的答案之一。其實父親的養生之道很簡單，唯「勤」一字而已。一直到去世之前，父親的畫筆從未停歇，仍然自己裝框裱畫；生活上他也堅持自立生活，不願接受子女的照顧。他殷殷勸大家作任何事都持之以恆，也教導我們子女不要因瑣事纏身而荒廢了一生的志業與興趣。

　　許多人覺得奇怪，三十多年來，父親雖長居堤波隴市，卻未在當地購屋置產，不識者說父親不懂理財。但從小耳濡目染父親的身教、言教，我們知道對父親來說，美國只是客居，心目中真正的家國卻只有一個。親近他的友人也都知道，儘管三十七年來"寒溪畫室"所陳列的作品經常遞換，但恆常不變的是父親每天早上在畫室門口昇起的兩面國旗—一面是他寄身的美國國旗，一面是他心之所繫的中華民國國旗。從安東街舊居到堤波隴客寓，父親的生活基本上沒有改變，他

仍然畫國畫、仍然閱讀中文報紙、仍然津津樂道於中華文化、台灣的發展以及台灣新生代的藝術家種種。所不同的是他在千里之外，是以實際生活去體現中華文化，也透過他的畫筆把中華藝術帶給他的外國友人。"寒溪畫室"接待過無數來自台灣的訪客，無論是政商名流、藝術藏家或是昔日故舊，父親均是熱忱接待，務求賓主盡歡，有時曲終人散而意猶未盡，父親便會揮筆作畫並題上：「有朋自遠方來，不亦樂乎！」以抒發情懷。

這就是我們的父親，一個平凡而又偉大、真情畢露的父親。我們子女四人，有幸在父親的薰陶下，雖在美國成家立業，但都對中國文化耳熟能詳，父親的孫輩也都與我們一樣，他們加入醒獅團，以身上流著中國人的血液為榮。也因為如此，在中華文化館藏豐富的國立歷史博物館舉辦紀念展，讓父親在台灣的親朋好友、門生故舊能與我們一起送父親最後一程，也讓台灣年輕的一代能有機會一睹父親的書畫藝術，實在是我們最希望為父親作的一件事。

我們劉家人要特別感謝國立歷史博物館安排這項展覽，給予父親這樣的殊榮；我們也要感謝它讓我們達成為人子女的心願。謹代表我們的父親向國立歷史博物館以及熱心的館方主事人員致最深的謝意。我們同時也要感謝協助這項展覽的朋友以及前來參觀的民眾，感謝他們與我們一起紀念我們的父親—劉業昭先生，也一起分享他的書畫藝術。

劉氏子女
劉興瑪、劉興珂、劉興後、劉興玳及其家屬
同叩謝
二○○五年

From The Liu Family

Han Syi Studio, the gallery of Liu Yeh-Jau, was established on the main street of Tiburon, California, and for thirty-seven years was a highlight of any visit to the town. Tiburon was a bustling railroad town at the beginning of the Twentieth Century but is now an upscale Mecca for anyone seeking upscale restaurants, boutique shops or high-end interior designers. A mere one hundred feet from Han Syi pulses San Francisco Bay with views of the Golden Gate Bridge, the San Francisco Skyline and the hill hugging fog common to both the Bay Area and the paintings of our father.

On any given day tourists would wander from shop to shop, passing many but always stopping before Han Syi Studio to look in the window. Although the painting displayed there was changed often, it was surrounded by the ever-present two flags; the red, white and blue of the American, as well as the blue, red and white star of the Taiwan Flag.

Our father, an American Citizen and despite the fact that he spent nearly forty years of his life in the United States, was first, foremost, and proudly Chinese. When two of his four children attended universities in California he never let it be forgotten that, despite a western education, the family's roots were in Taiwan. Dinner discussion often centered on Taiwan's development and her new, emerging artists.

From the time we lived on Andong Je until our final goodbye, there was always discussion of the "proper way", Chinese Painting, Chinese Opera and the importance of keeping these ideas alive, even far from our homeland. Even the fact that he voted in the United States, in conversation with friends and clients he considered himself a "Guest" in America. On occasion he may even sign a painting as such.

At Han Syi, few days would pass that he would not be greeting someone from Taiwan, a dignitary, an artist, a collector or an old friend. These times were always joyous and inevitably, perhaps the next day, he would sign an inspired painting with the words "Joy is having visitors come from afar".

It is because his life in the United States was so intertwined with Taiwan, Chinese History and Art that this exhibit of his work at the National History Museum is

such a fitting and natural way to say good-bye. Not only is it an opportunity for the young people of Taiwan to examine how his art progressed and remained fresh, but it provides a focus for those in Taiwan who knew him or of him, his students, and his friends to wish him well on his new journey.

Our family, as well as our extended family both here in Taiwan, worldwide and the United States, bring to the National History Museum deep and many thanks for the opportunity of this exhibit. We recognize the honor this brings to our father and we would like to offer our appreciation and gratitude. We would also like to recognize the exhibit staff and supporting friends for their diligence and devotion to this project.

Finally, we would like to thank the people of Taiwan who have come to visit and share this special time of art, culture and remembrance.

With Respect,

Liu Shing Ma, Liu Shing Ko, Liu Shing Ho, Liu Shing Dai, their spouses, Liu Yeh Jau's six grandchildren, and special friend, Chris Morrison

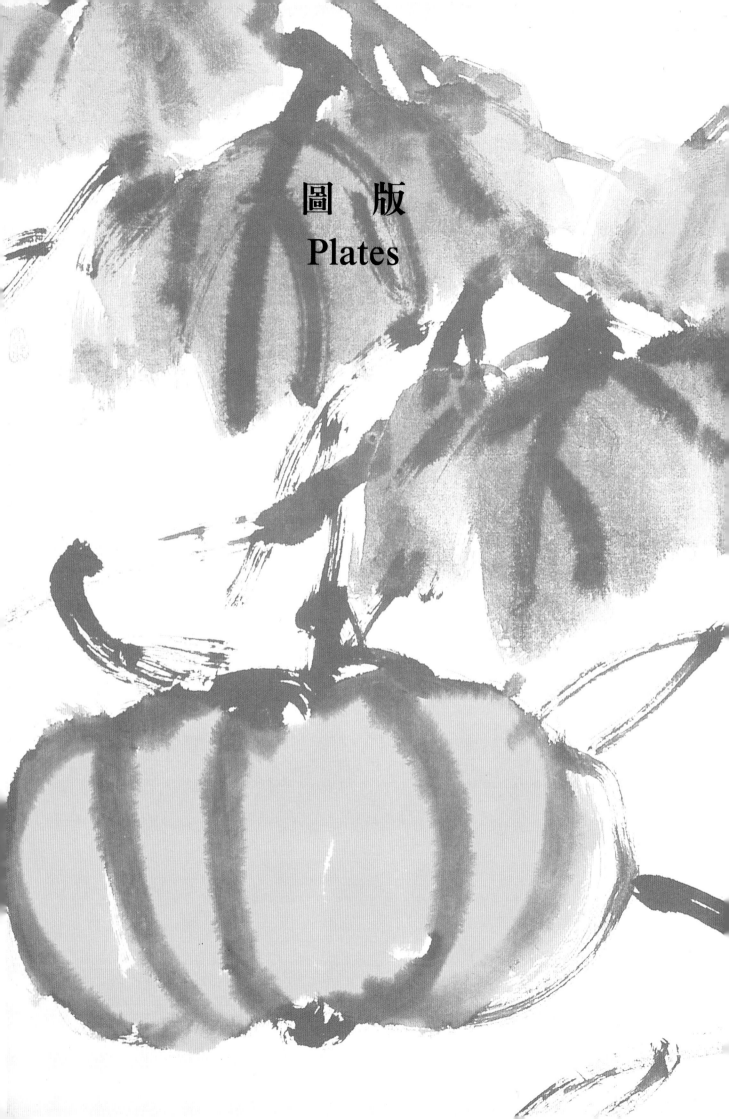

圖　版
Plates

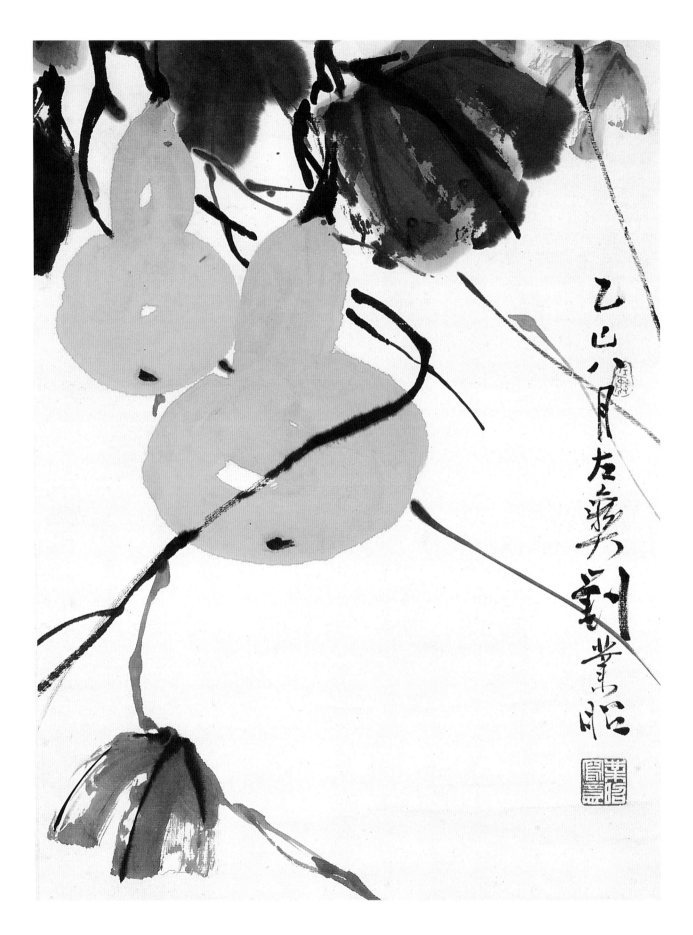

葫蘆

Yellow Gourds

47×35cm

1965

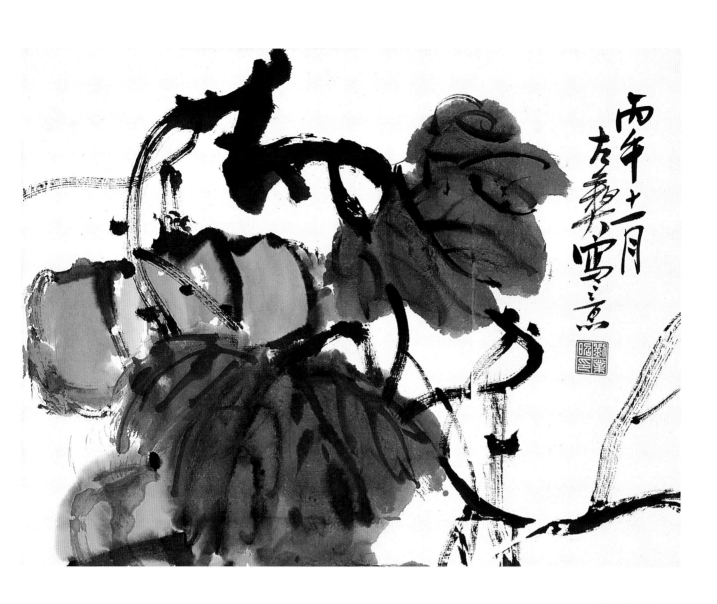

橘色南瓜
Yellow pumpkin
34×46cm
1966

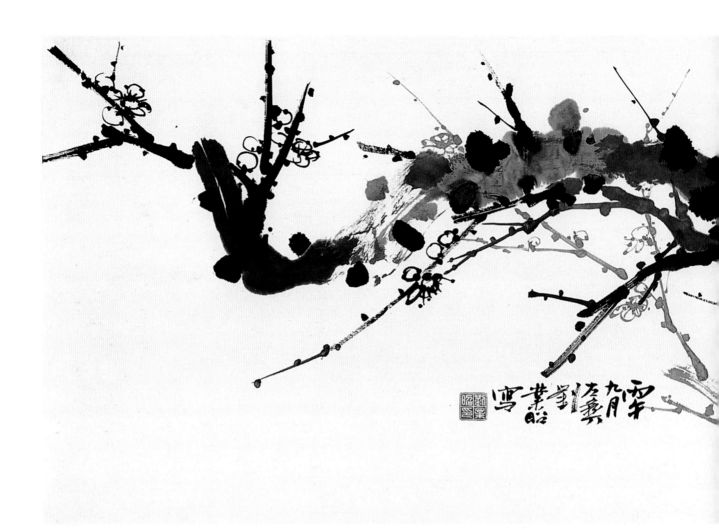

墨梅
Plum Blossom
40×121cm
1966

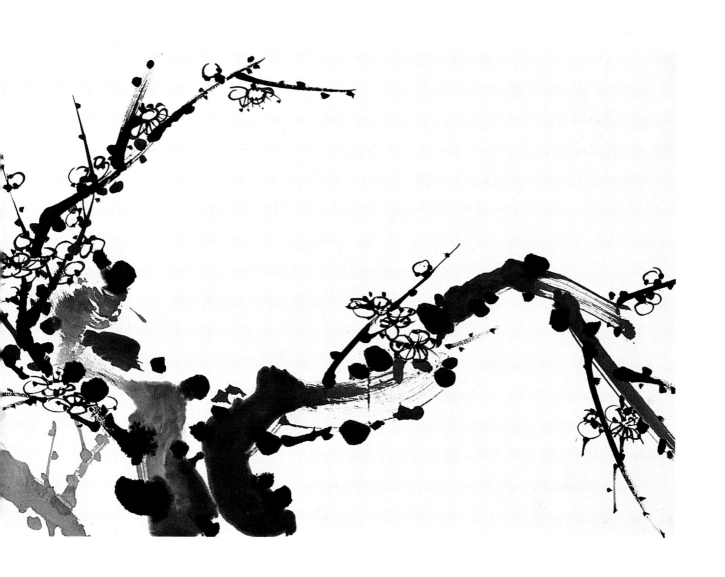

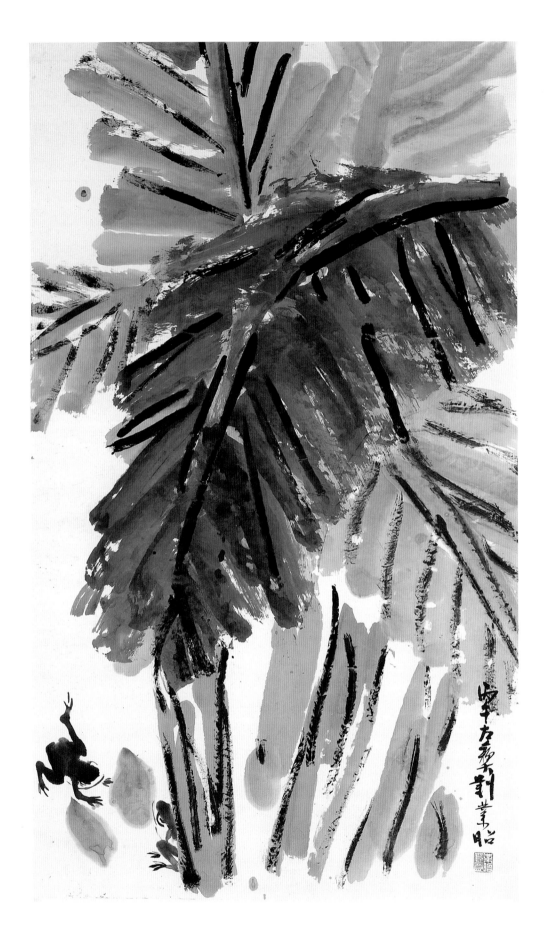

芭蕉和青蛙
Banana Tree and Frogs
113×68cm
1966

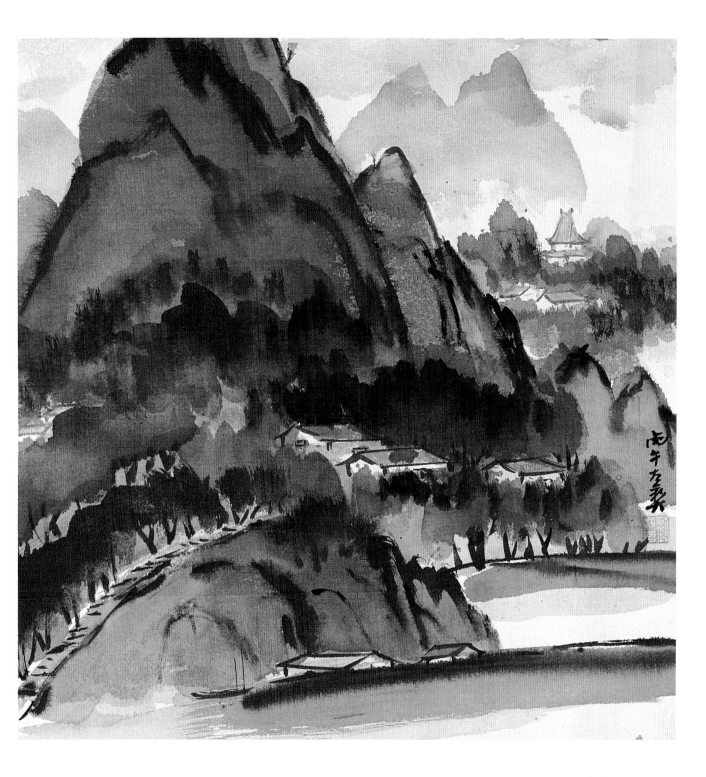

山水
Landscape on silk
47×47cm
1966

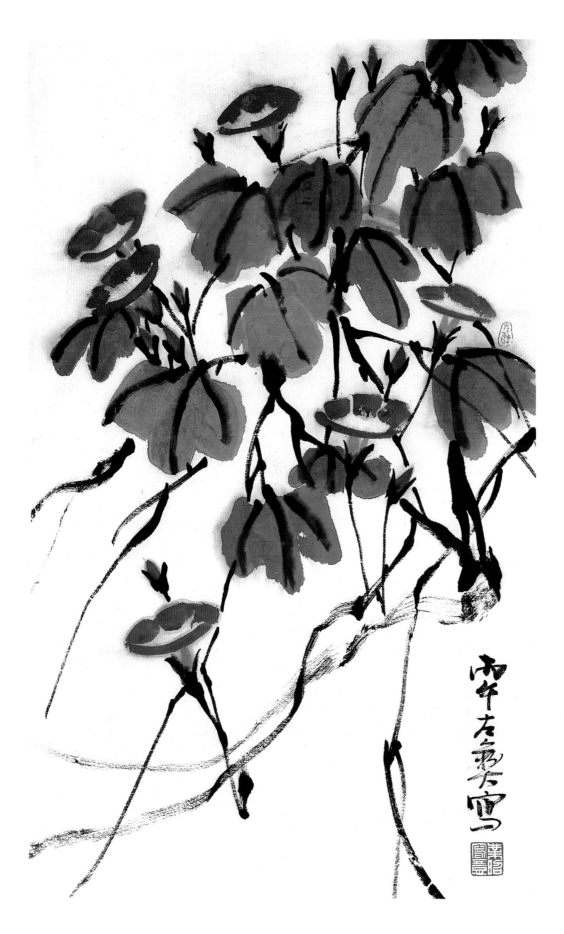

牽牛花

Morning Glory

68×41cm

1966

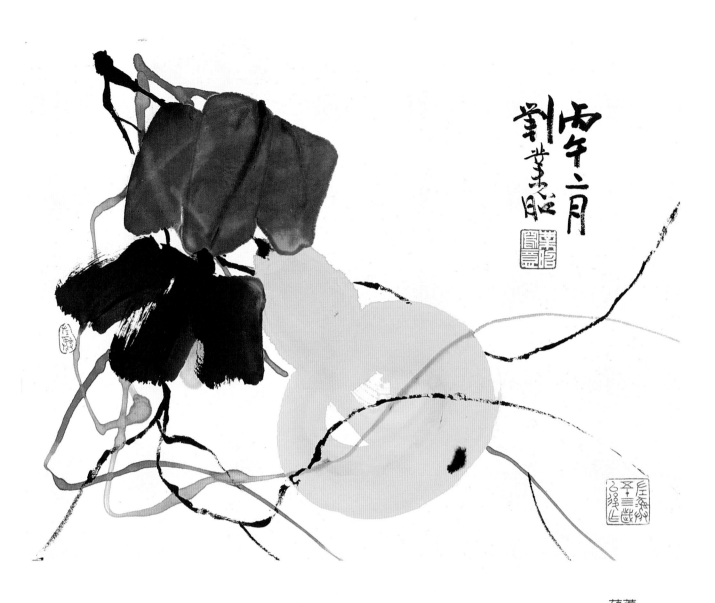

葫蘆
Gourds
34×46cm
1966

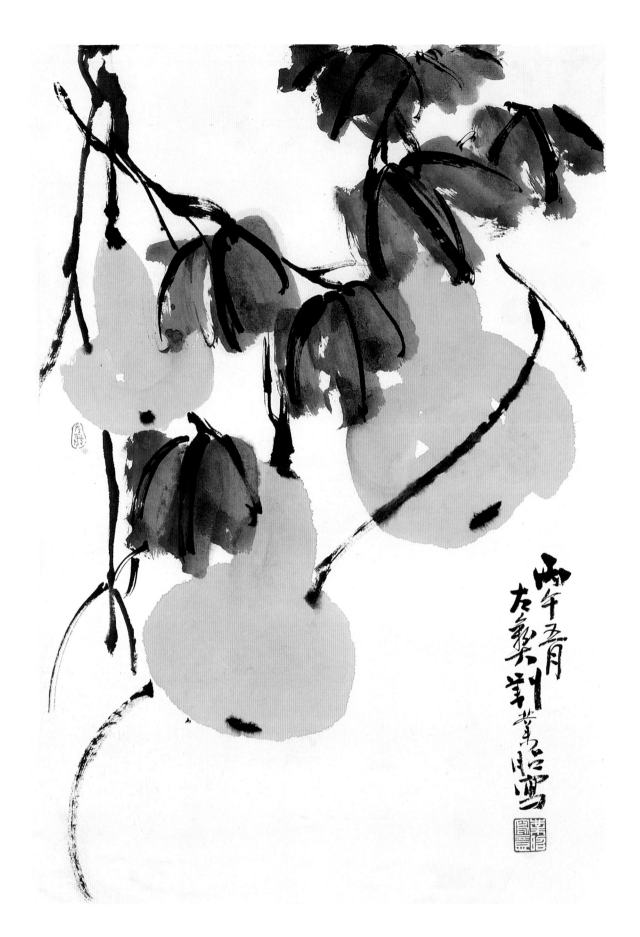

葫蘆

Yellow Gourds

67×45cm

1966

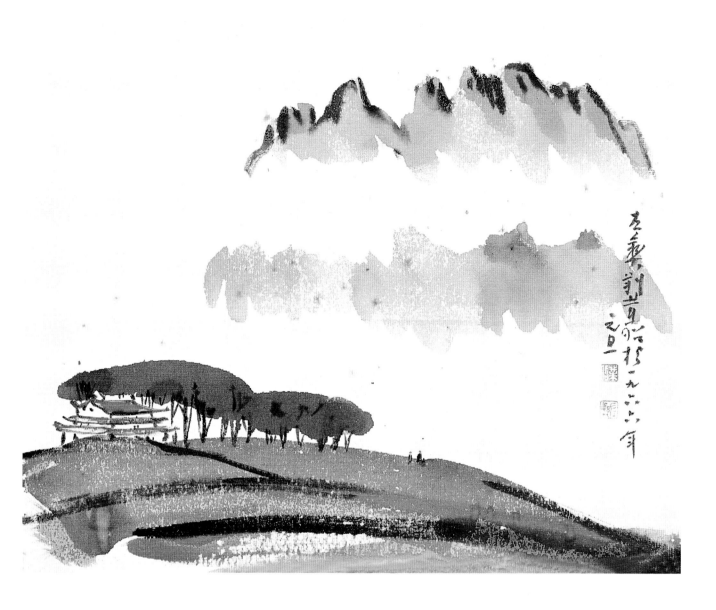

山水
Landscape
24×29cm
1966

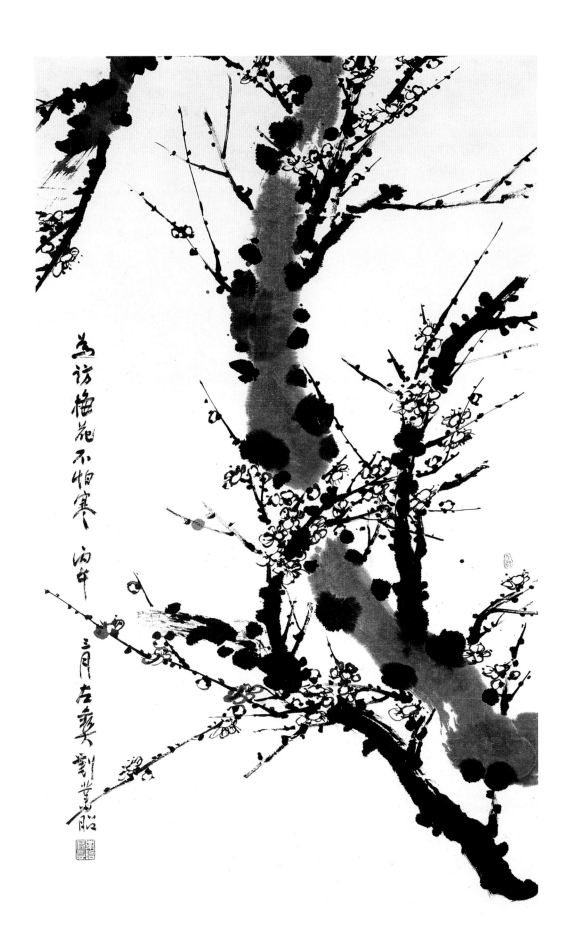

墨梅
Plum Blossom
110×66cm
1966

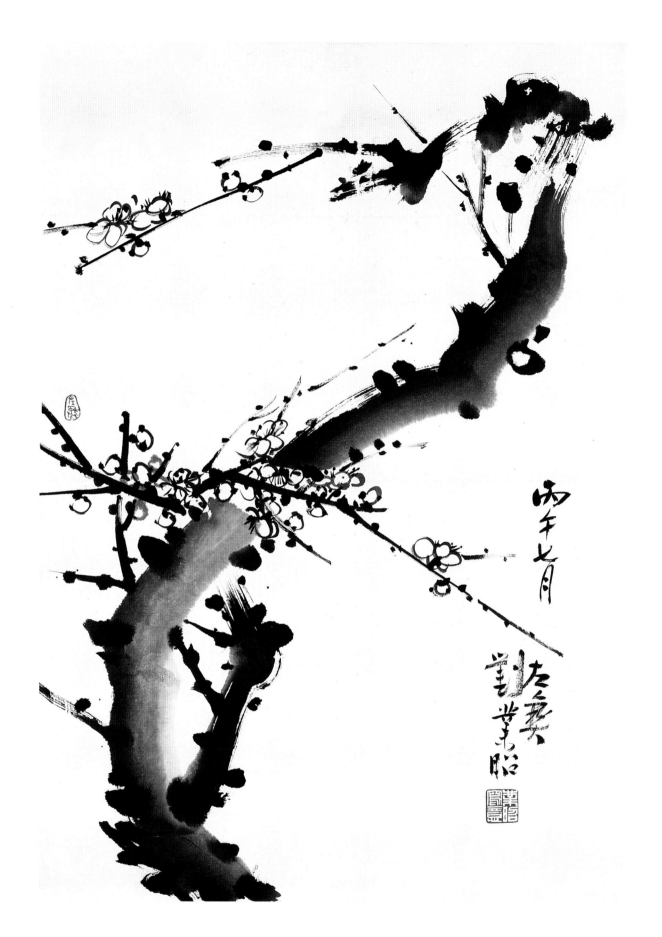

墨梅
Plum Blossom
67×46cm
1966

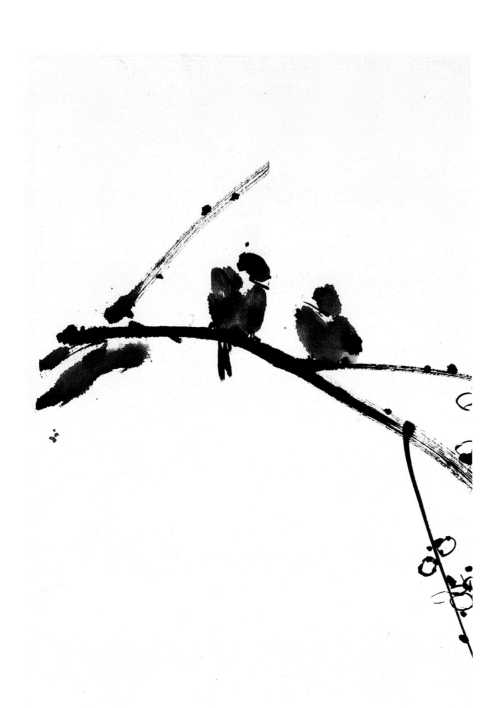

雙鳥棲息梅枝上
Two Birds on Plum Branch
67×32cm
1966

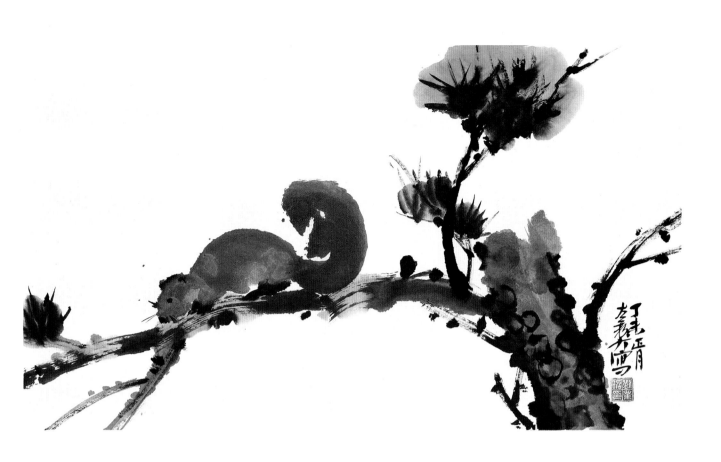

松鼠/松枝
Squirrel on Pine Tree
38×67cm
1967

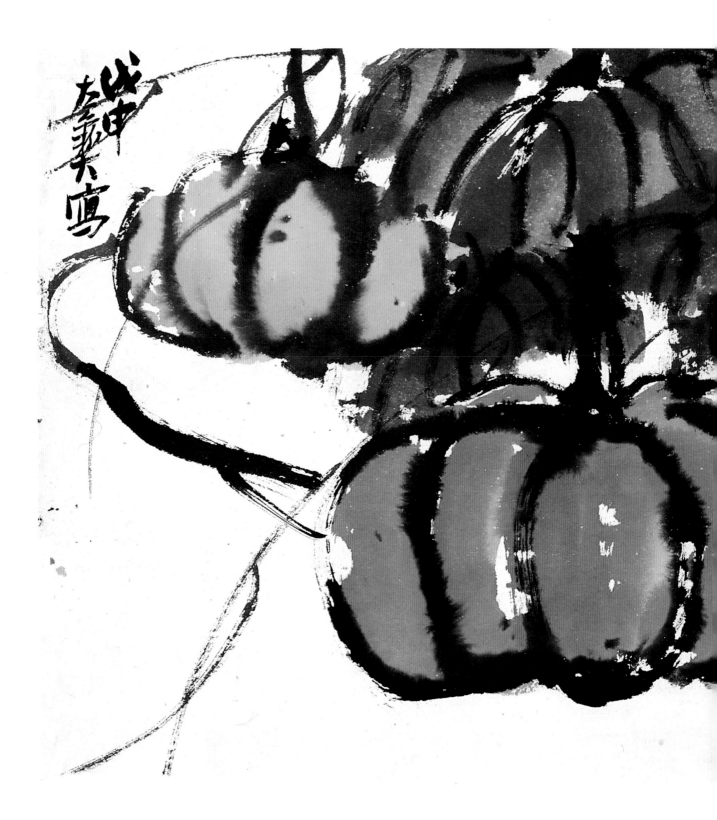

南瓜
Pumpkin
47×93cm
1968

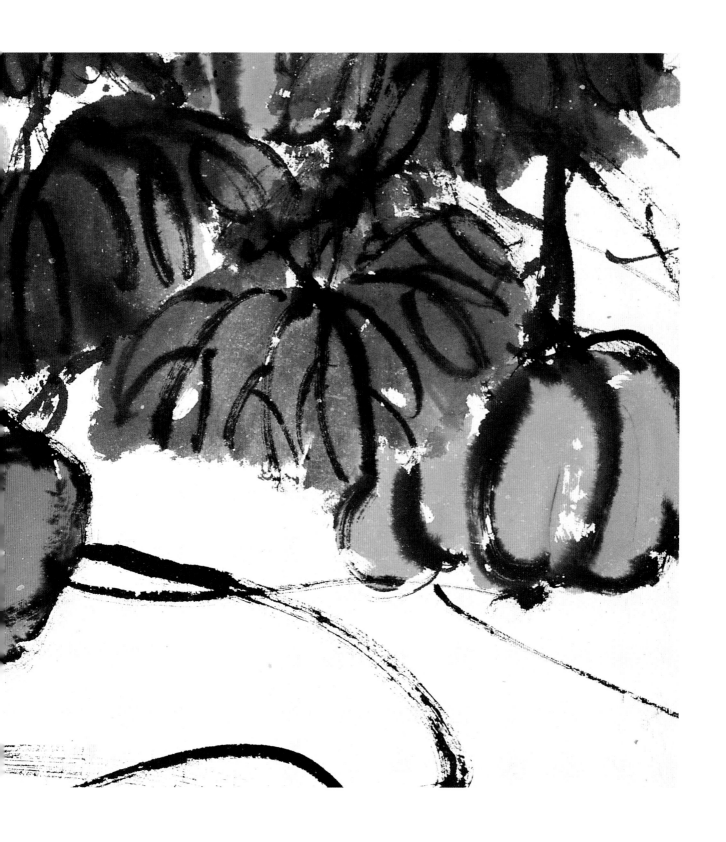

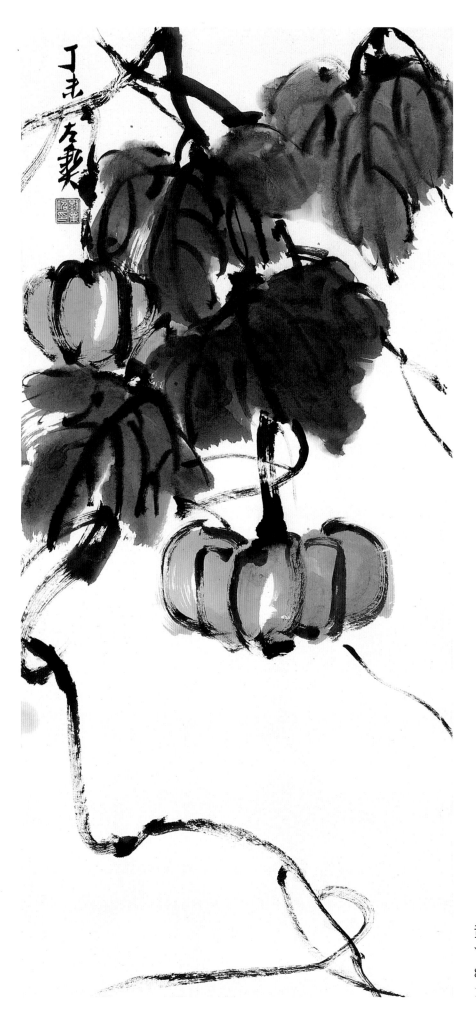

黃色南瓜
Yellow pumpkin
87×40cm
1967

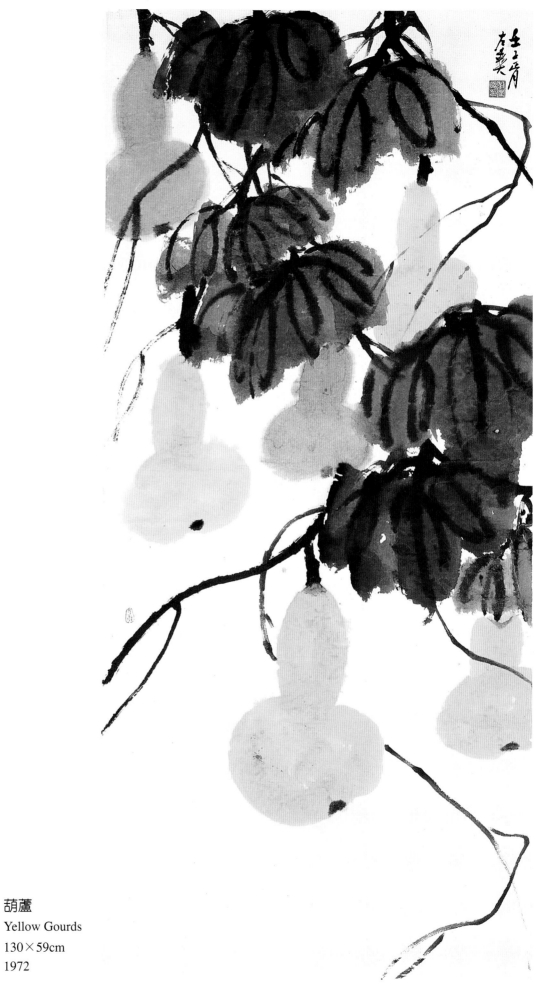

葫蘆
Yellow Gourds
130×59cm
1972

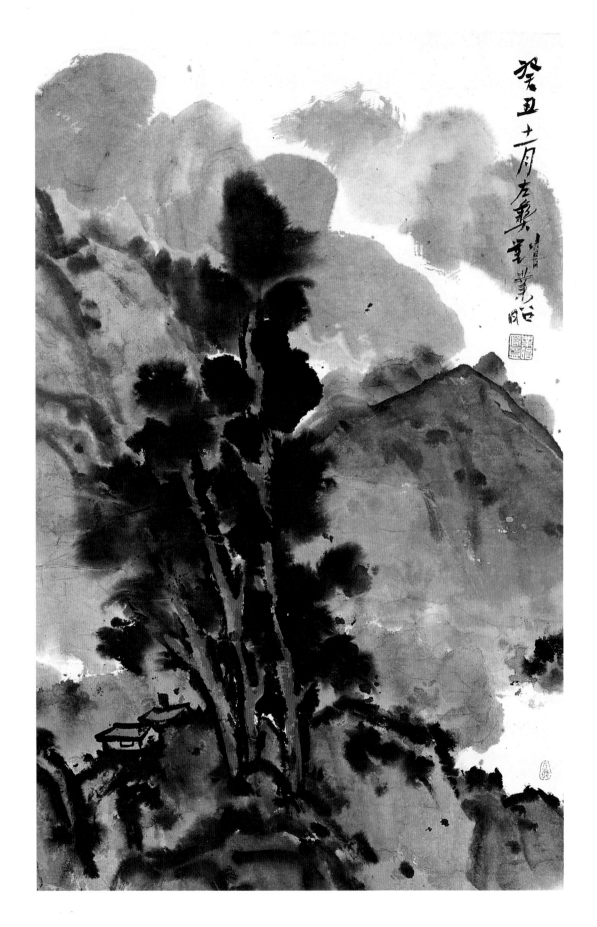

山水
Landscape
88×56cm
1973

44

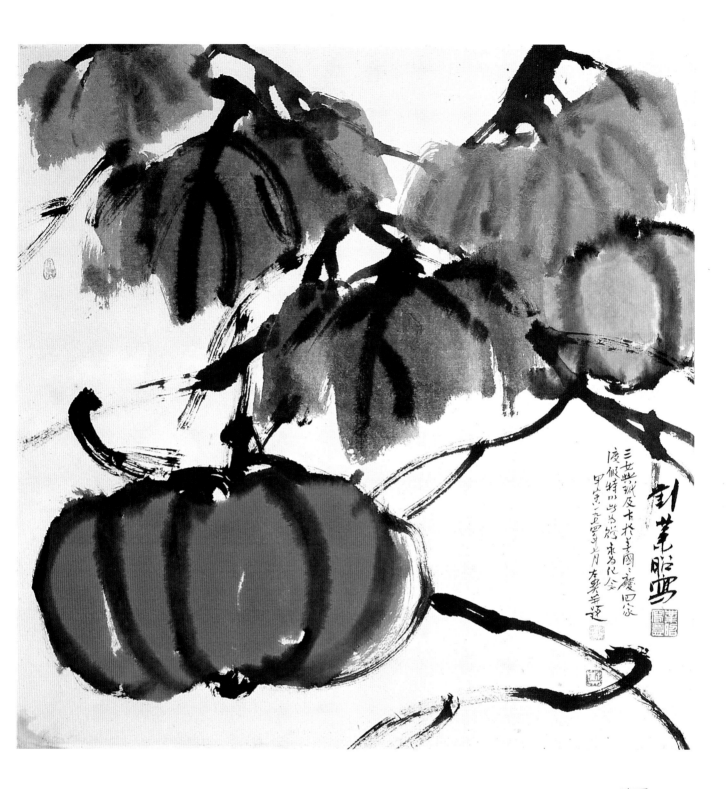

南瓜
Pumpkin
66×65cm
1974

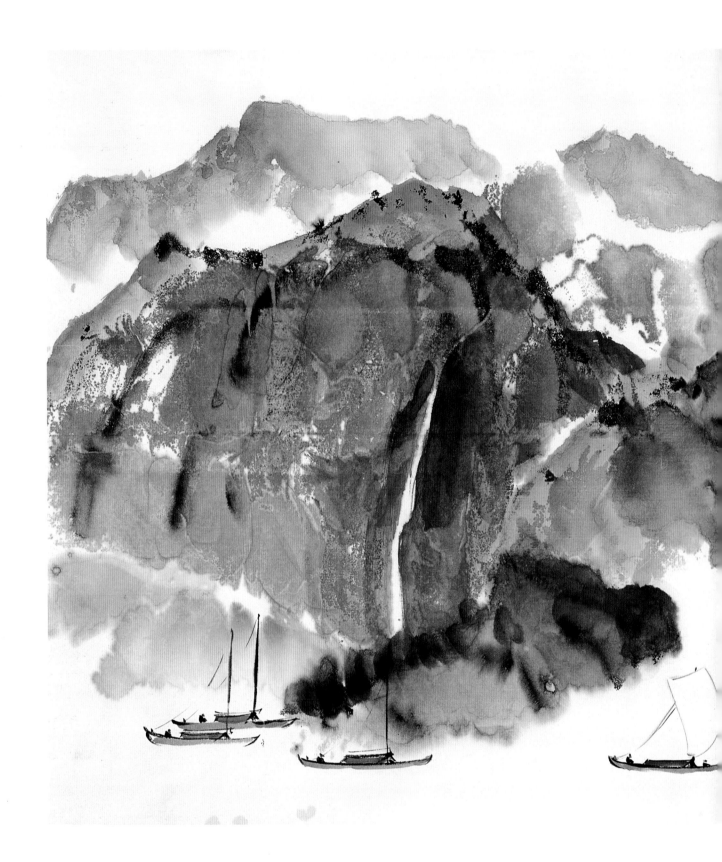

山水
Landscape
67×128cm
1975

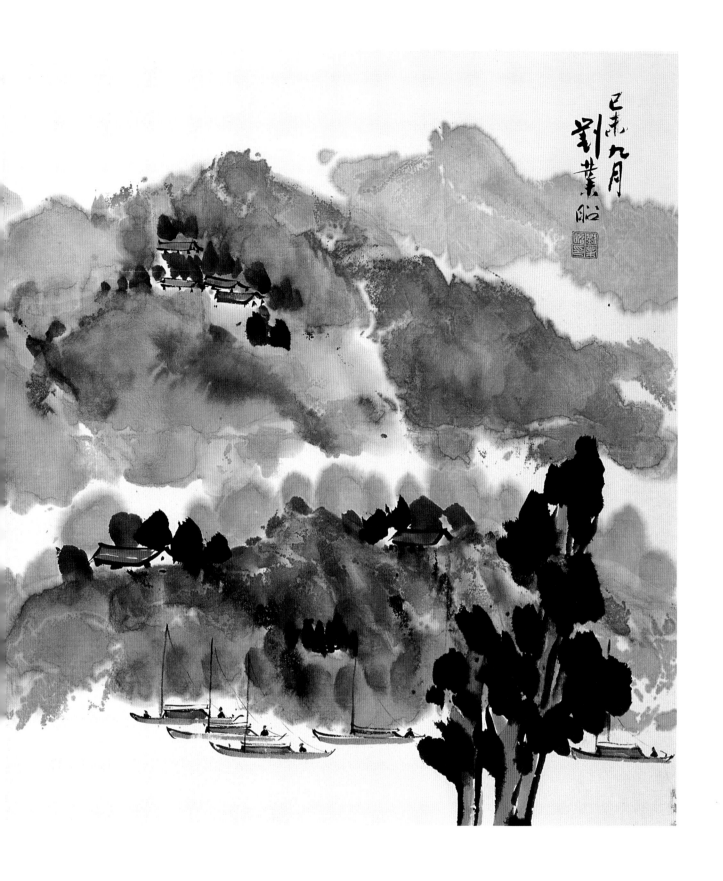

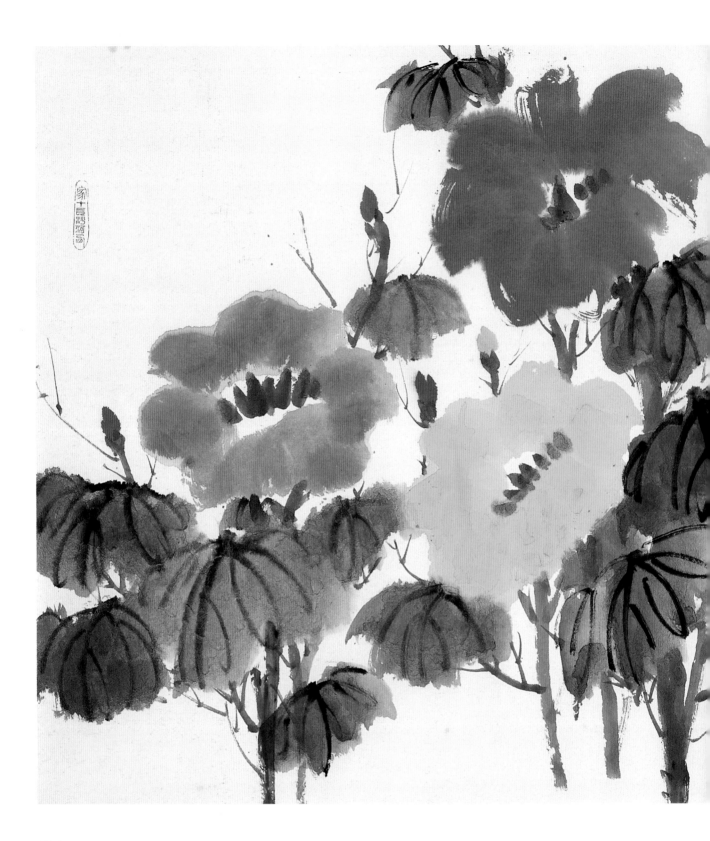

花卉
Yellow and Red Flowers
66×129cm
1975

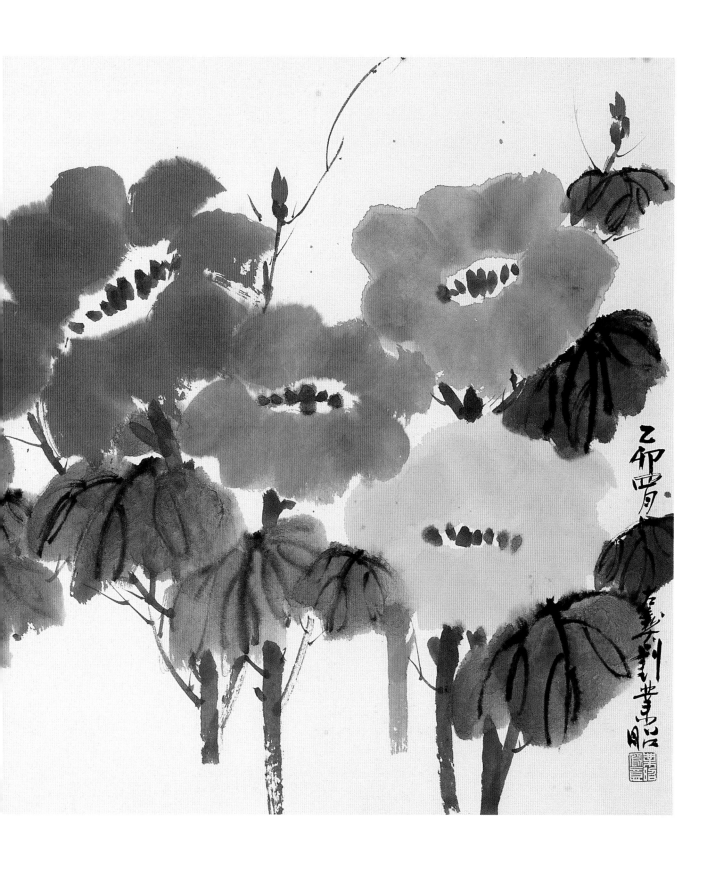

49

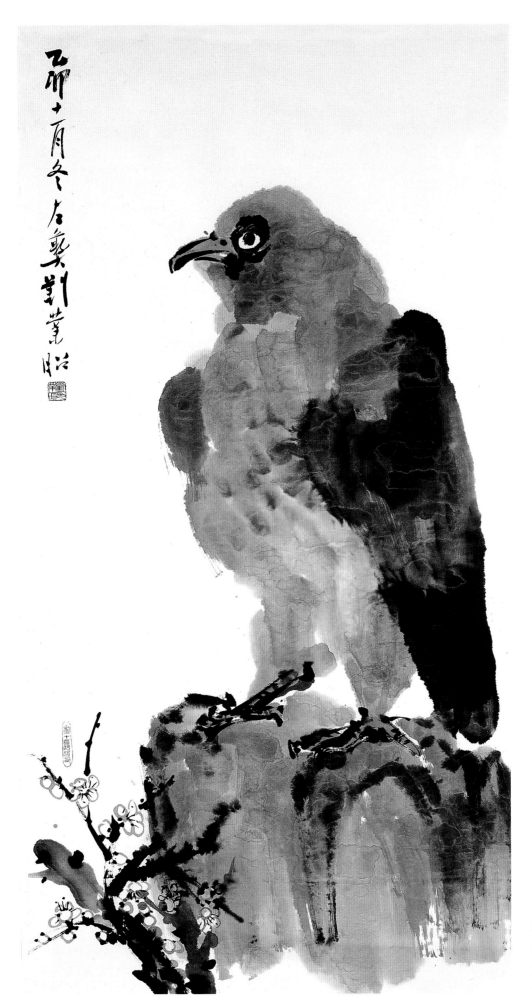

老鷹
Eagle /Plum Blossom
130×38cm
1975

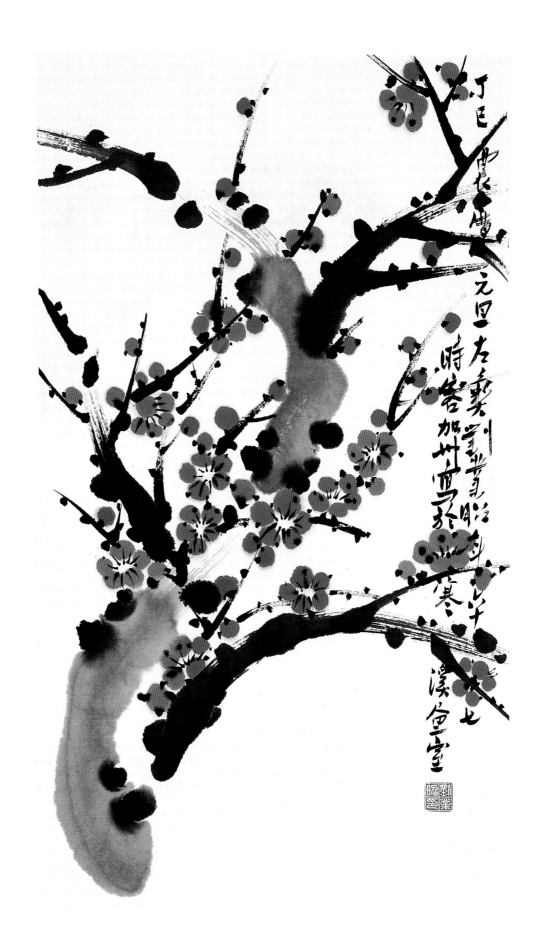

紅梅
Red Plum Blossom
68×39cm
1977

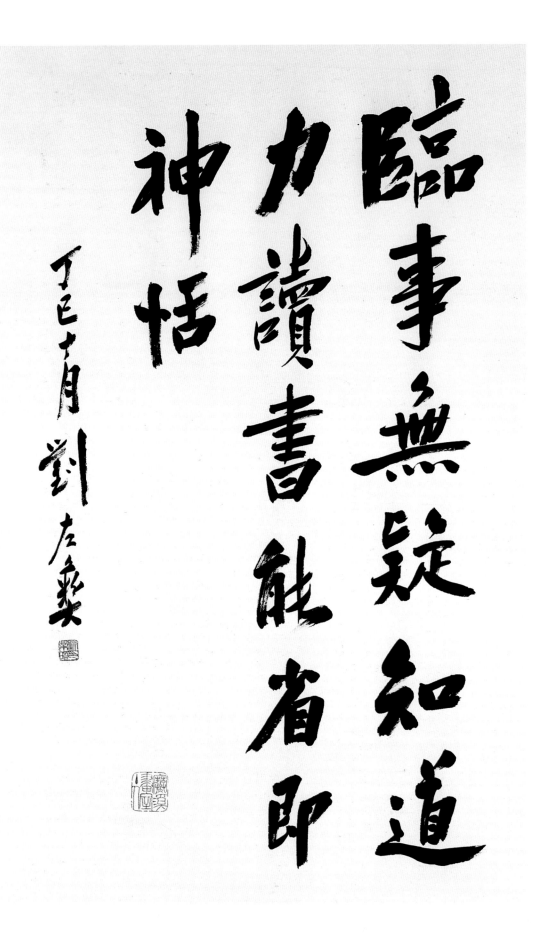

書法
Calligraphy
113×70cm
1977

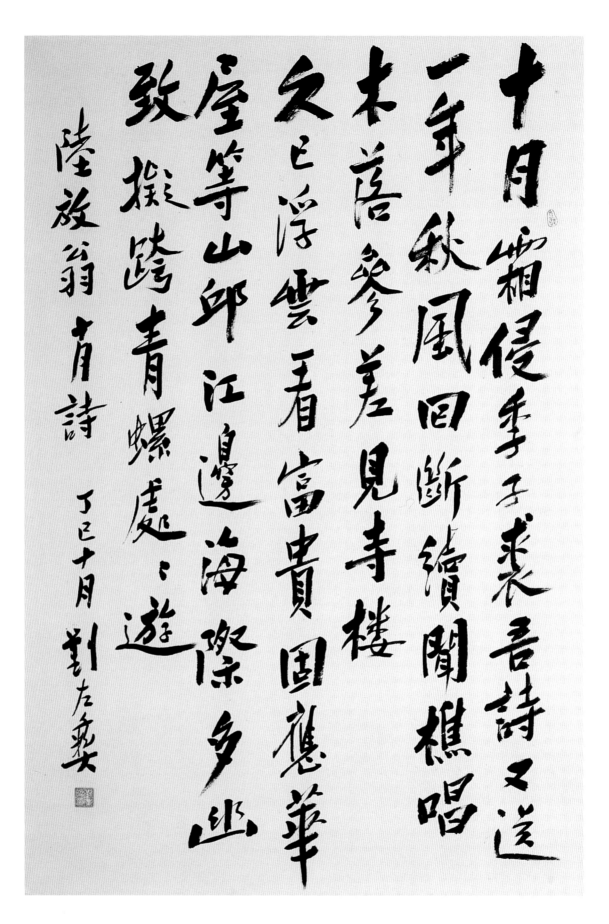

書法　陸放翁十月詩
Calligraphy
104×73cm
1977

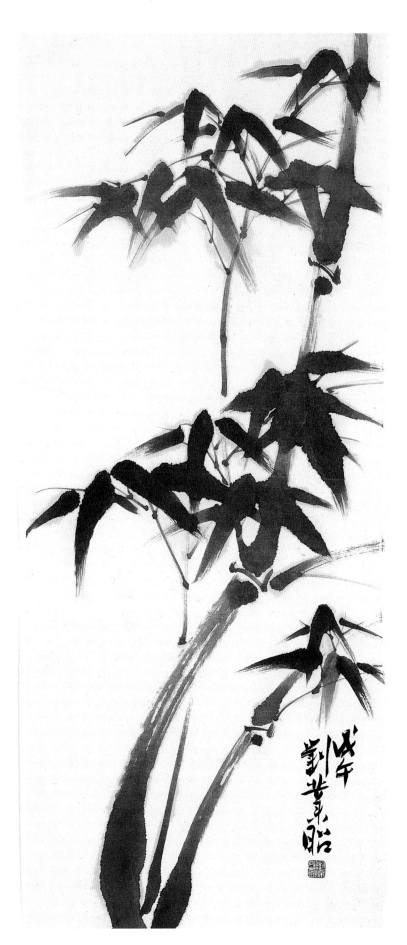

綠竹
Green Bamboo
70×29cm
1978

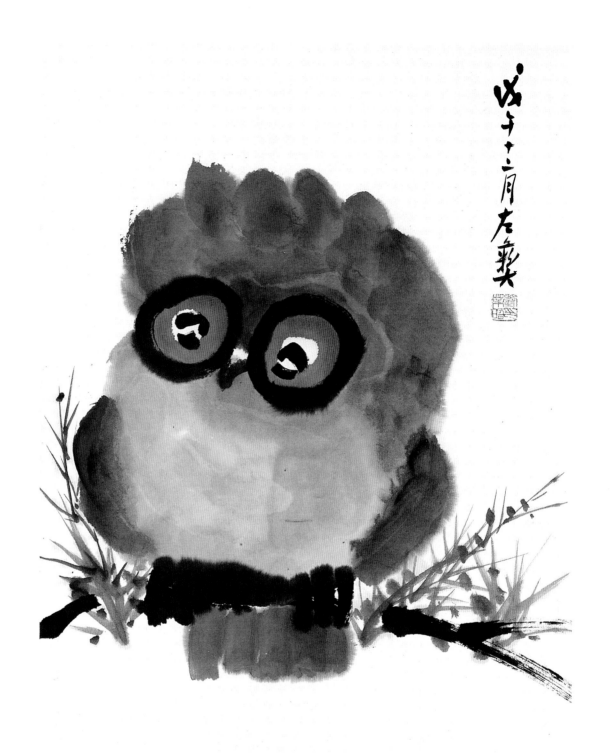

貓頭鷹
Owl on Pine Branch
66×51cm
1978

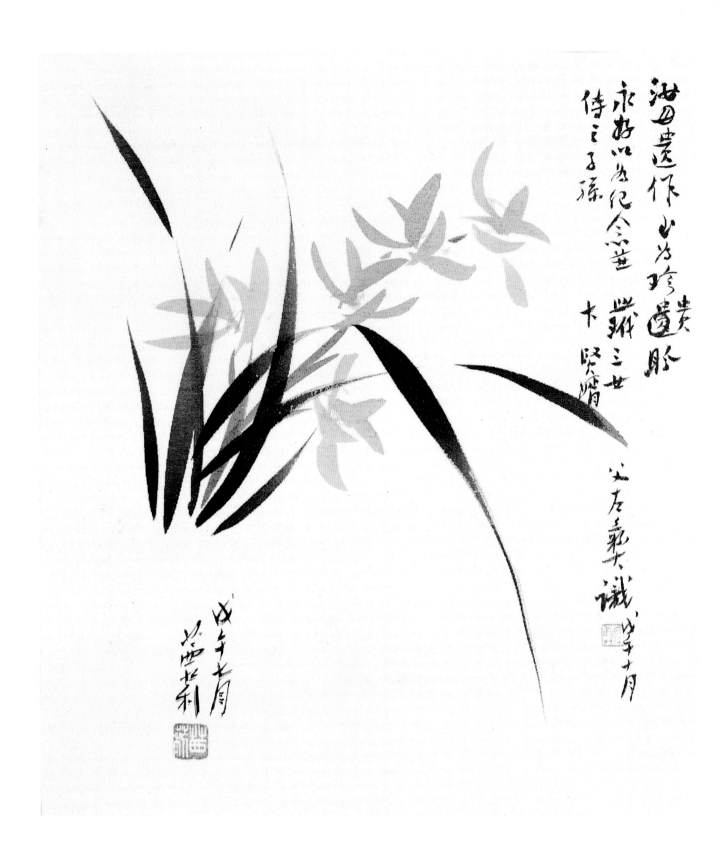

蘭花
Orchid
51×41cm
1978

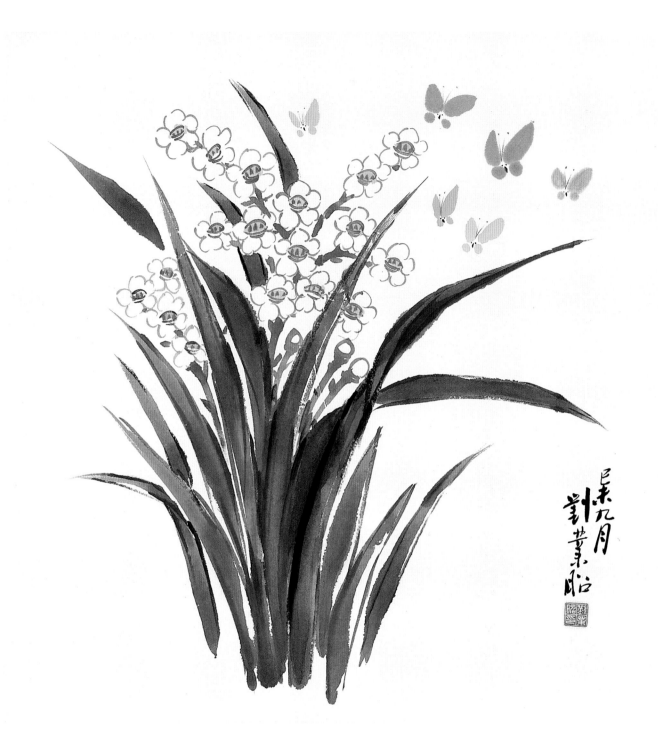

水仙花
Narcissus
67×65cm
1979

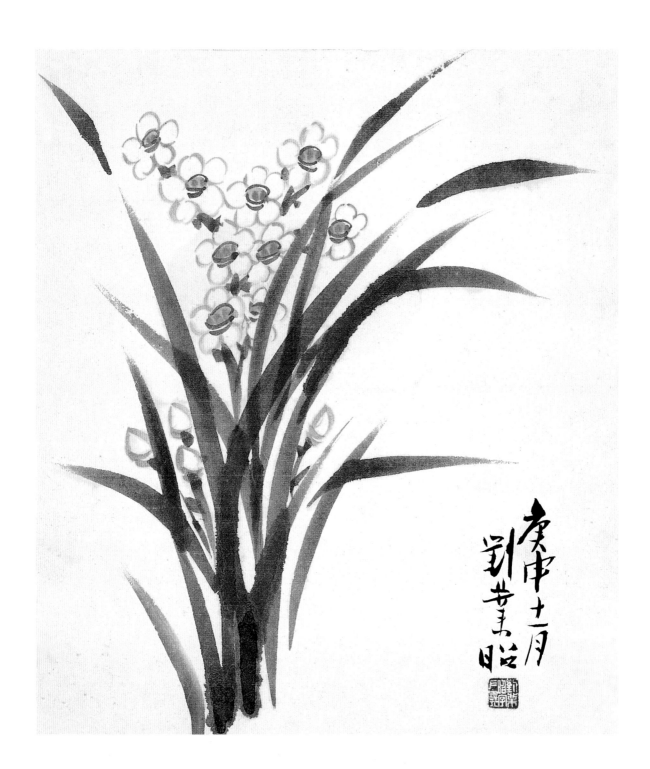

水仙花

Narcissus

32×28cm

1980

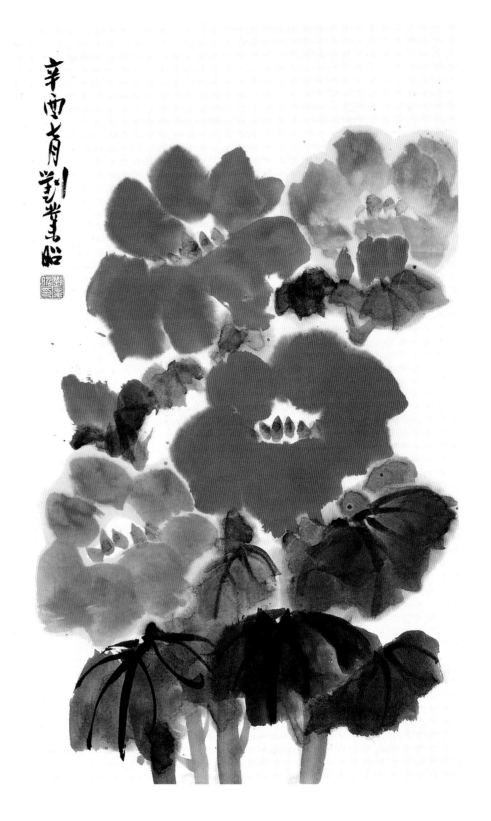

花卉
Flowers
72×43cm
1981

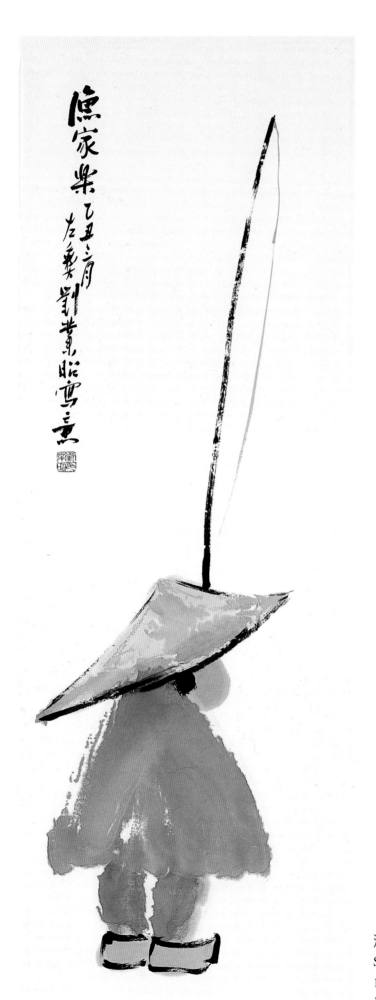

漁翁
Single Fisherman
123×41cm
1985

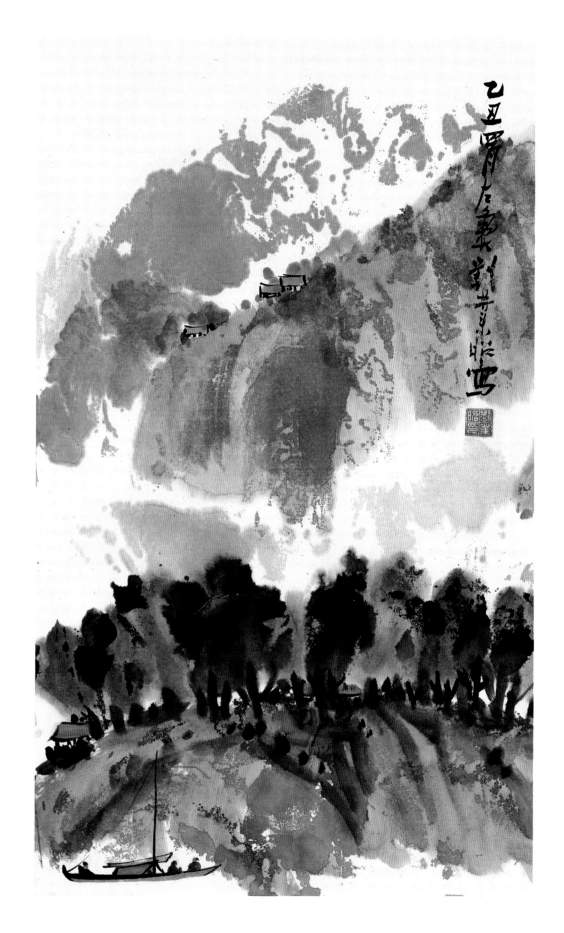

山水
Landscape
70×42cm
1985

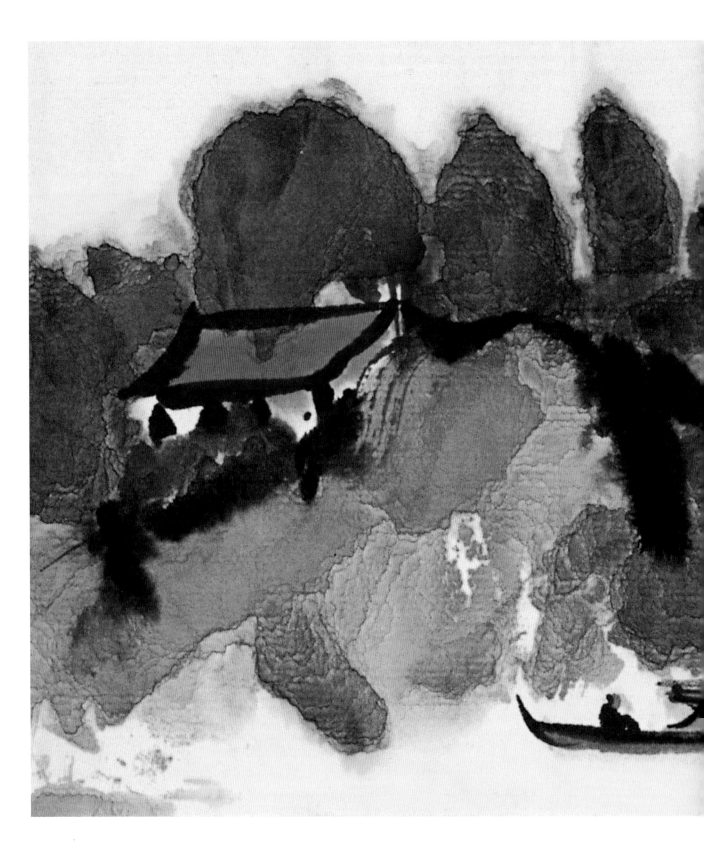

山水
Landscape
11×20cm
1987

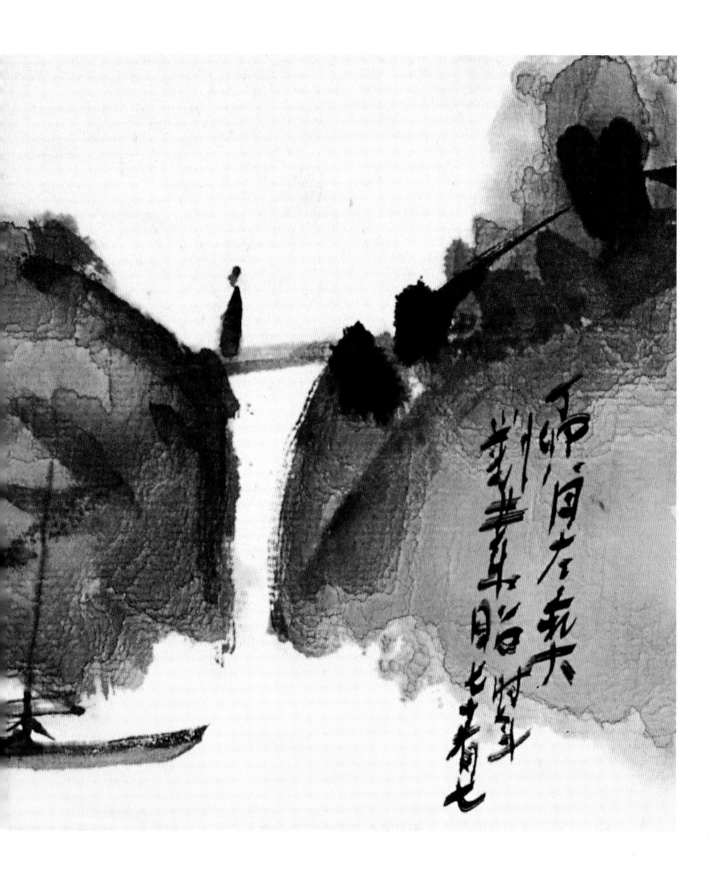

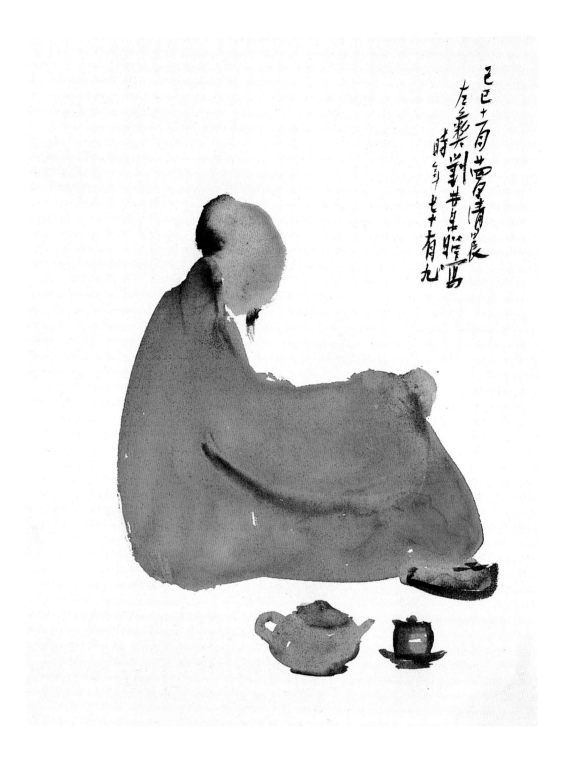

詩人
Sitting Poet
41×32cm
1989

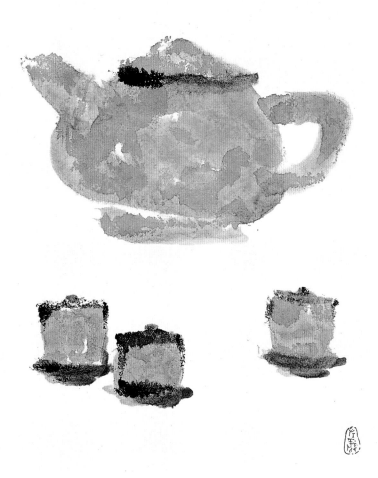

茶具
Teapot and Cups
70×33cm
1989

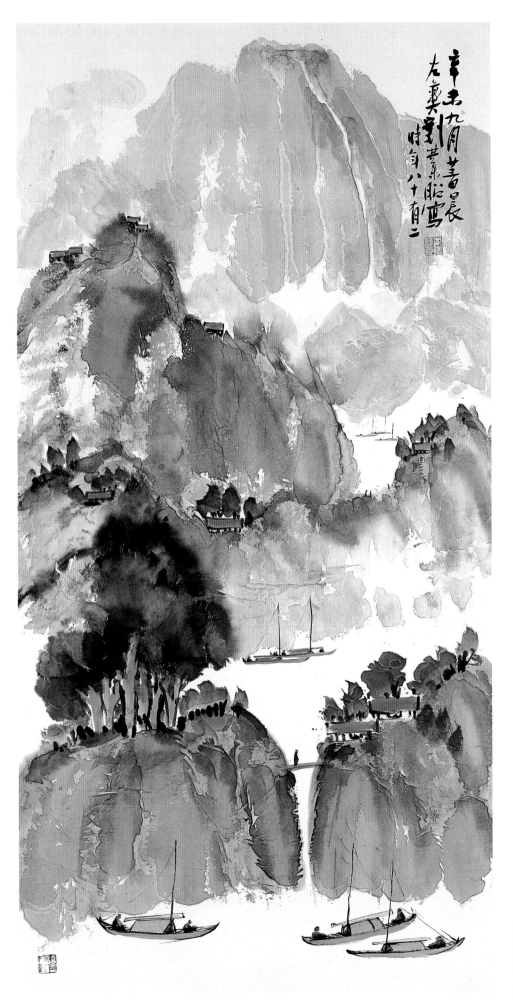

山水 船
Landscape with boats
137×70cm
1991

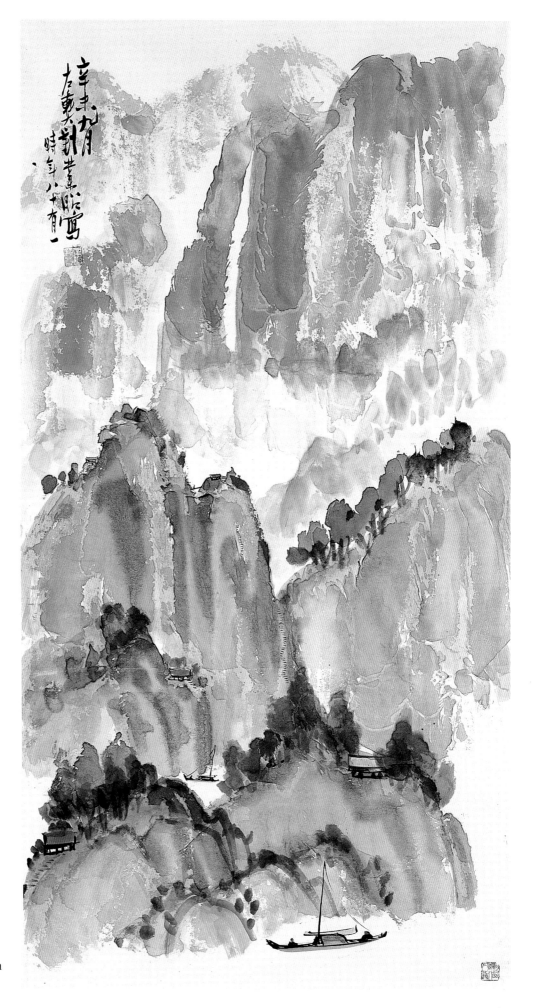

山水
Landscape
134×70cm
1991

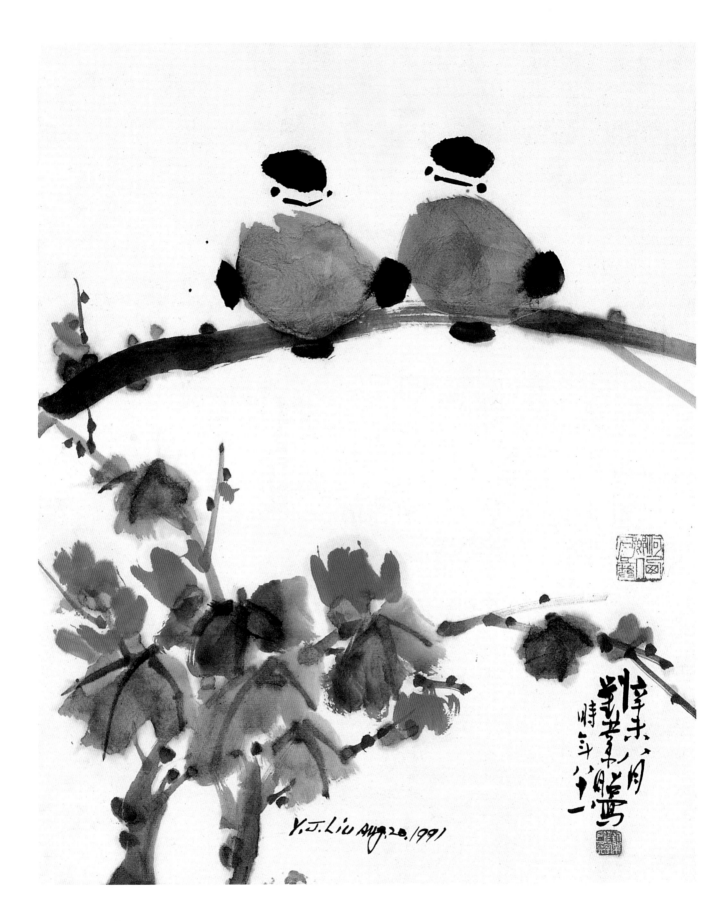

雙鳥棲息花枝上
Two Birds on Flower Tree
52×38cm
1991

老去原知萬事空但悲不見九州同王師北定中原日家祭毋忘告乃翁

宋陸放翁詩

辛未孟秋
劉業昭
時年六十一

書法　陸放翁詩
Calligraphy
62×46cm
1991

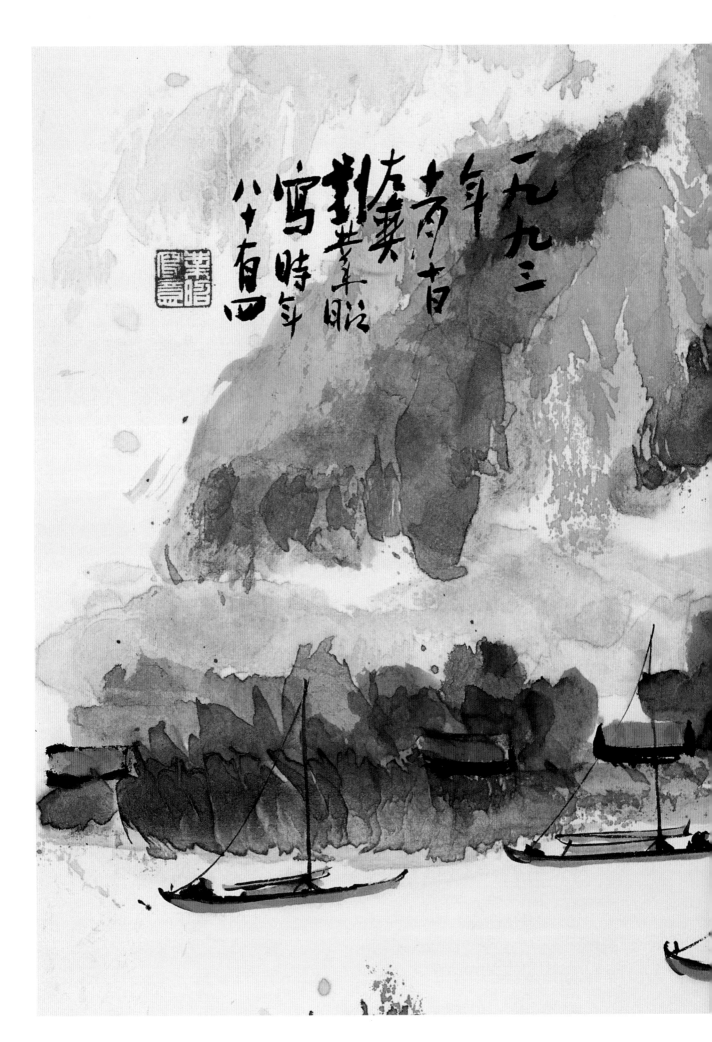

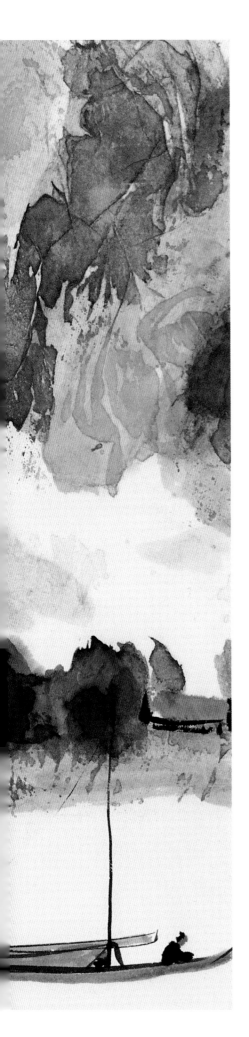

寫山隨意似遊山
Landscape
44×45cm
1993

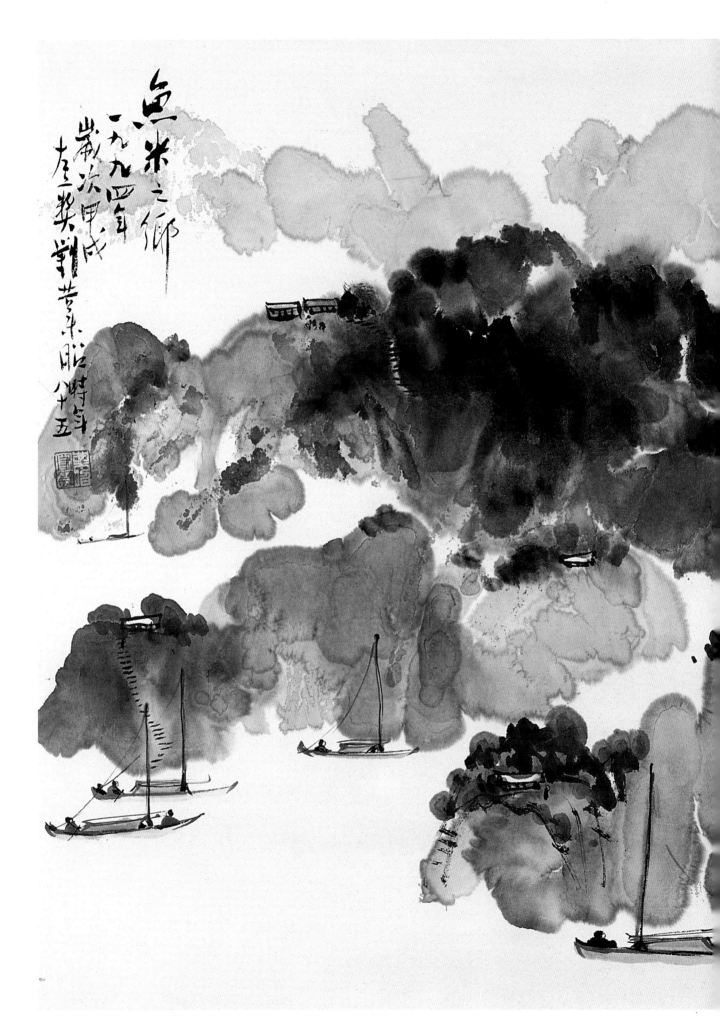

魚米之鄉
一九九四年
歲次甲戌時寫
左奬劉蒼未眠八十五

72

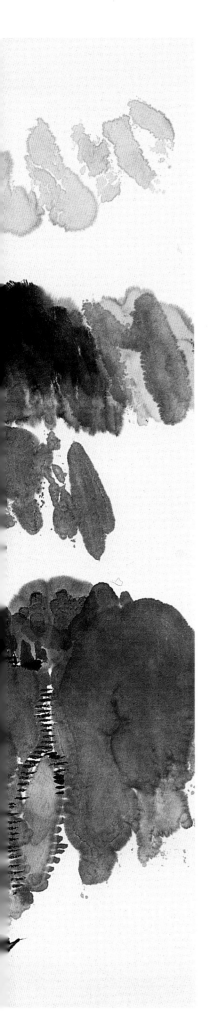

墨色山水
Landscape
70×68cm
1994

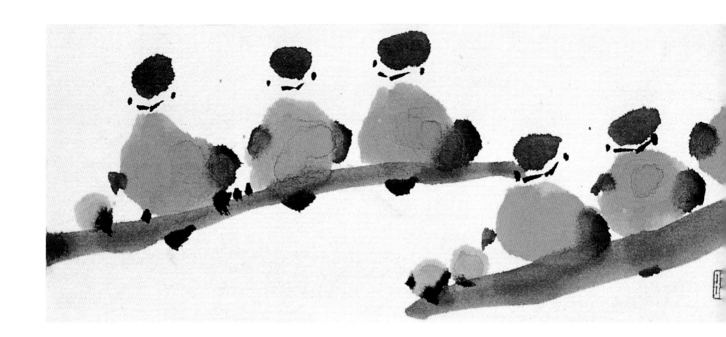

群鳥
Flock of Birds
8×36cm
1995

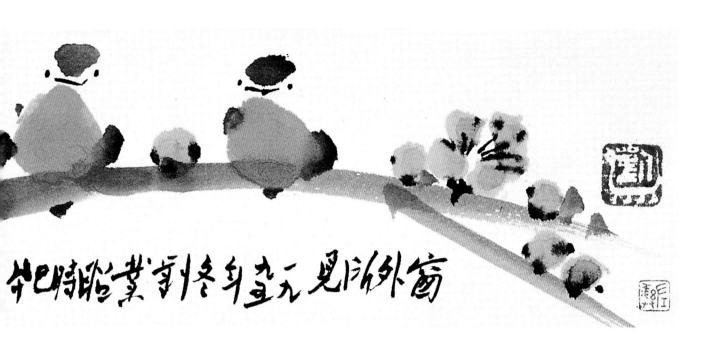

窗外所見　元旦立冬年到寒賞其點了呆時巴乜牛

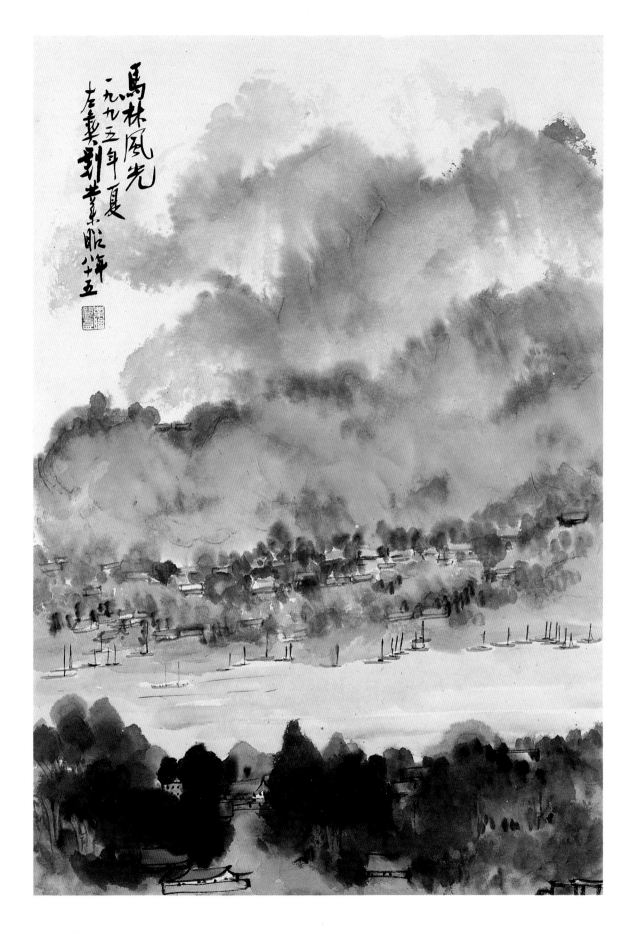

山水　美國馬林郡

Marin Landscape

93×64cm

1995

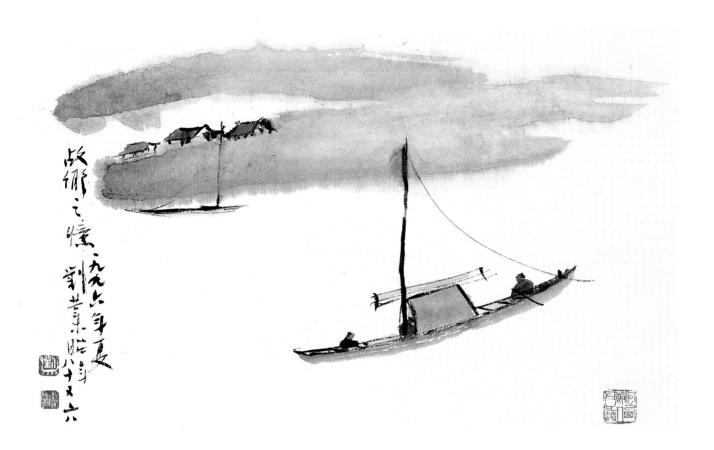

故鄉之懷 一九九六年夏 劉業昭寫於八十又六

船
Boat
29×50cm
1996

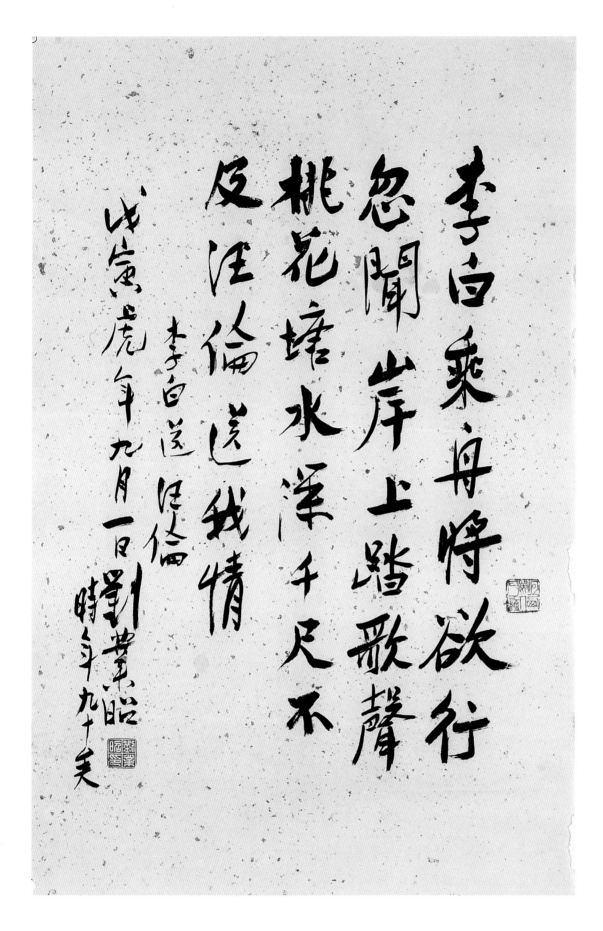

李白乘舟將欲行
忽聞岸上踏歌聲
桃花潭水深千尺不
及汪倫送我情

李白送汪倫

戊寅虎年九月一日劉業昭
時年九十又

書法 李白詩
Calligraphy
66×42cm
1998

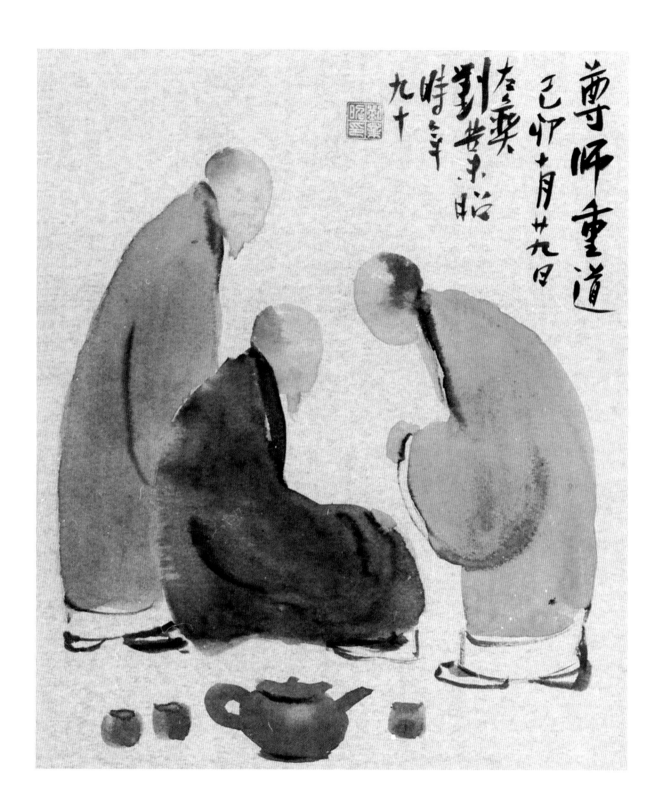

尊師重道
Figures
58×52cm
1999

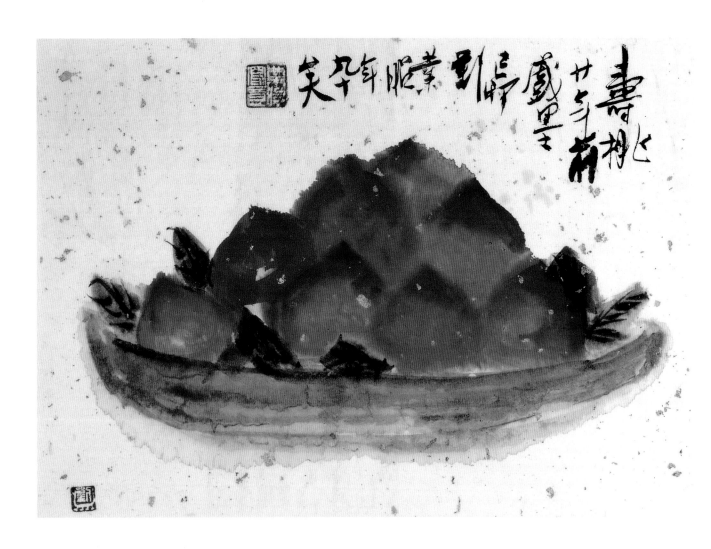

壽桃
Long Life Peach
28×43cm
1999

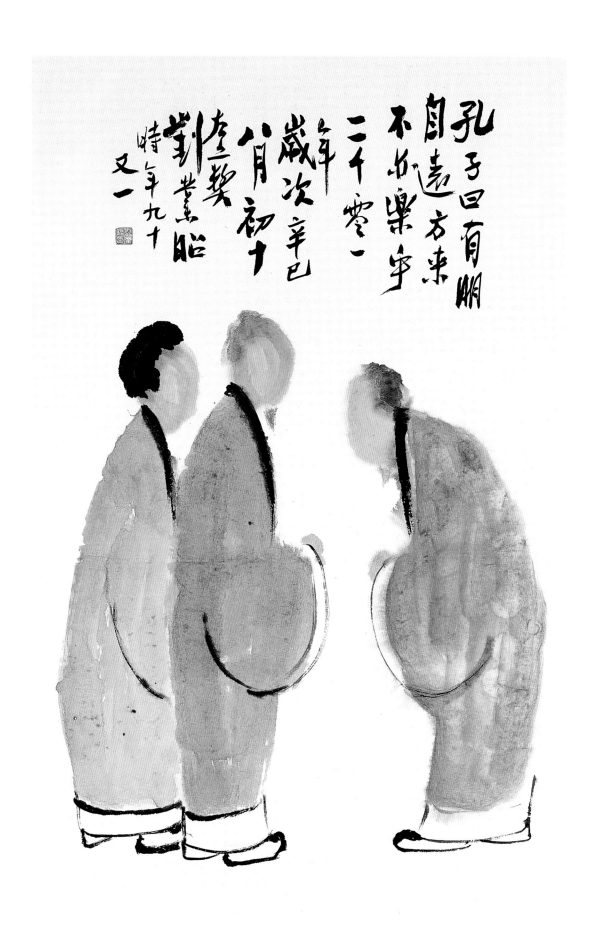

孔子曰有朋
自遠方來
不亦樂乎
二千零一
年
歲次辛巳
八月初十
李奎龍□
劉業昭
特年九十
又一

三位詩人
Three Poets
120×70cm
2001

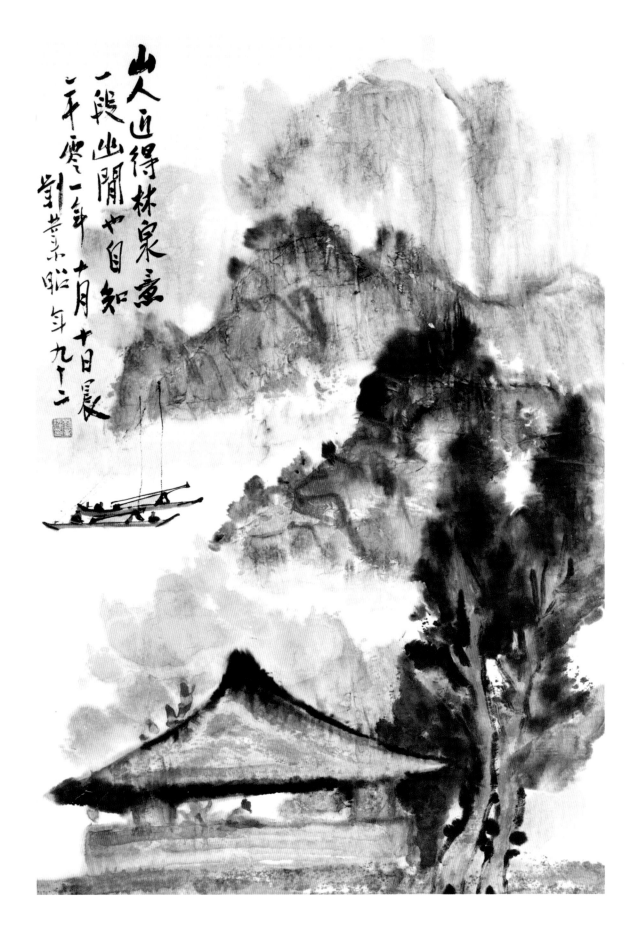

山水
Landscape
110×75cm
2001

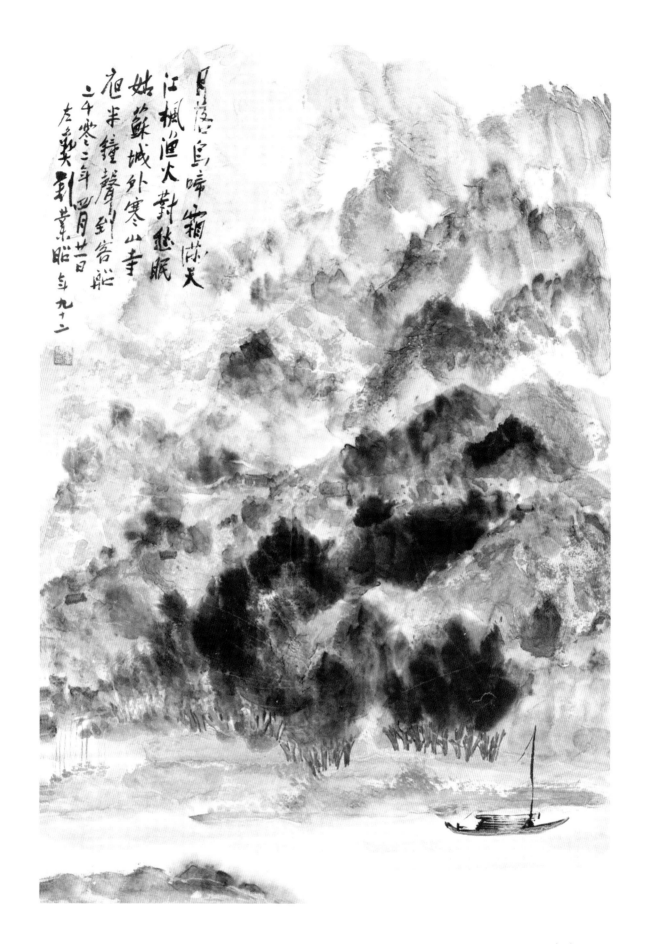

月落烏啼霜滿天
江楓漁火對愁眠
姑蘇城外寒山寺
夜半鐘聲到客船

二千零二年四月廿日
左筆笑劉業昭年九十二

山水
Landscape
104×74cm
2002

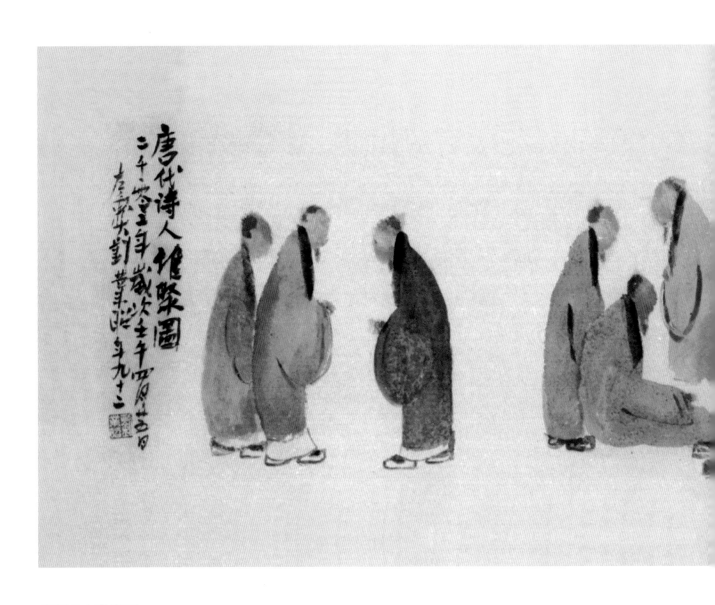

唐代詩人雅聚圖
Tang Dynasty Poets
12×40cm
2002

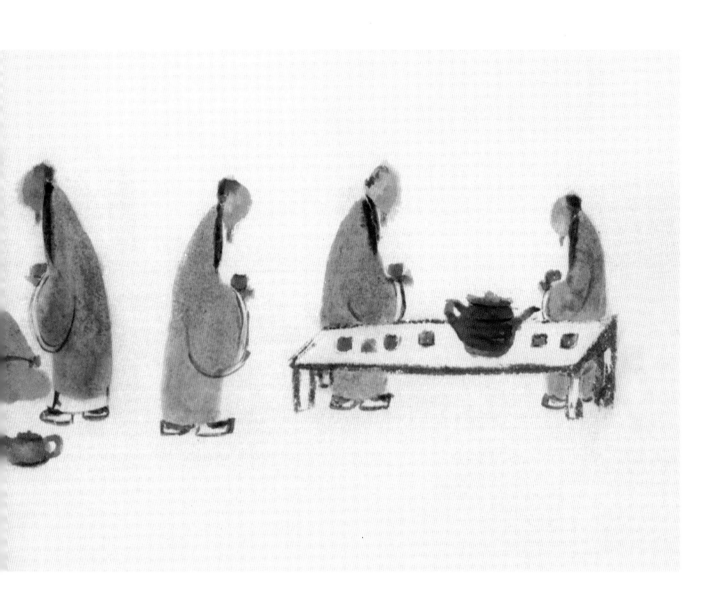

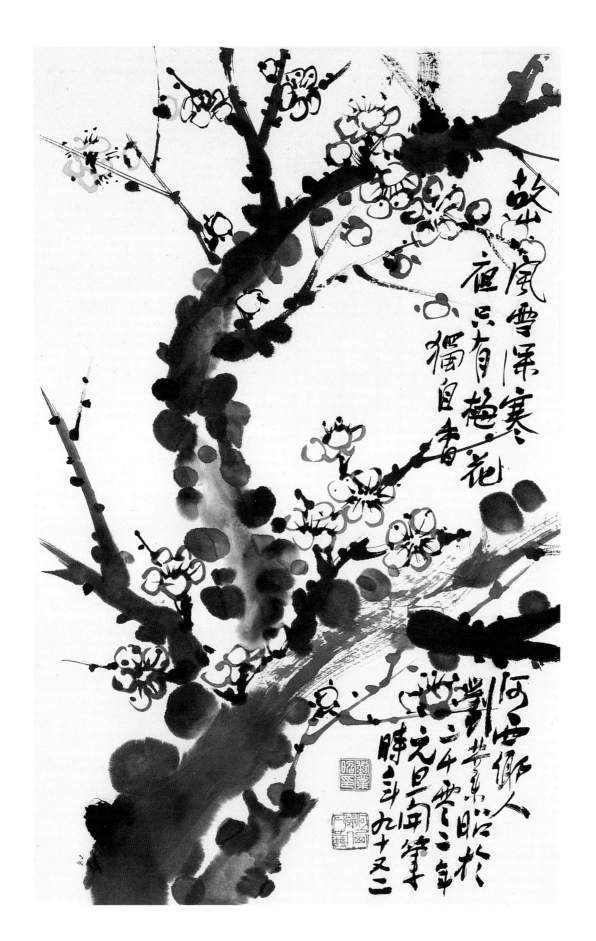

墨梅
Plum Blossom
60×38cm
2002

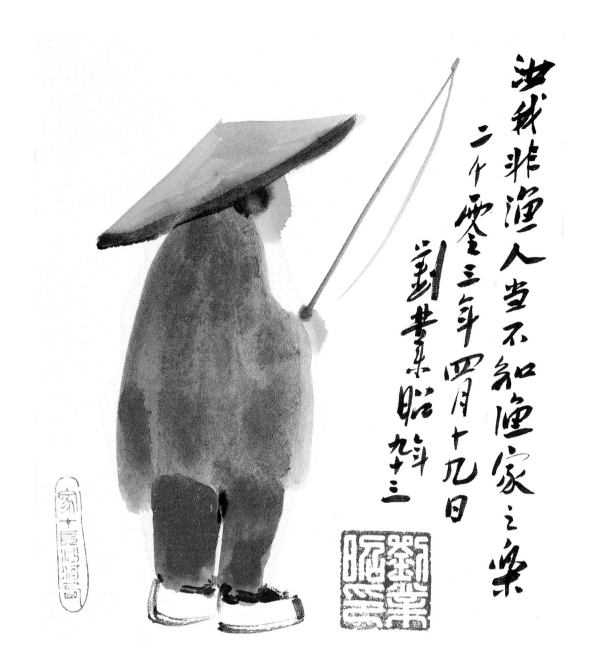

汝我非漁人豈不知漁家之樂　二〇〇三年四月十九日　劉業昭龄九十三

漁翁
Fisherman
27×24cm
2003

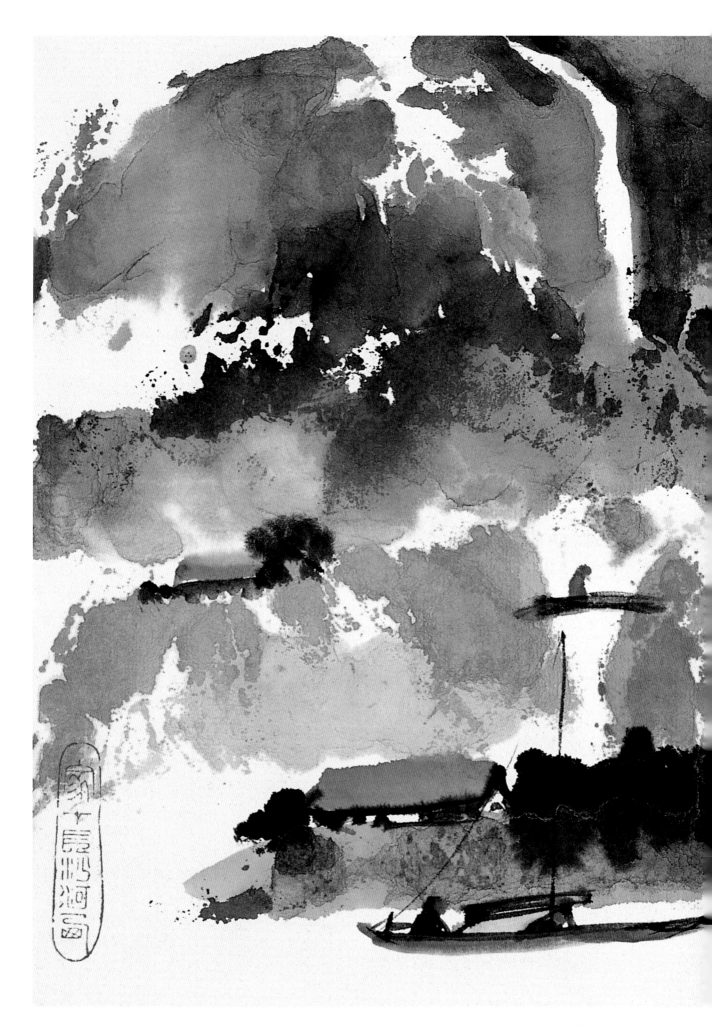

88

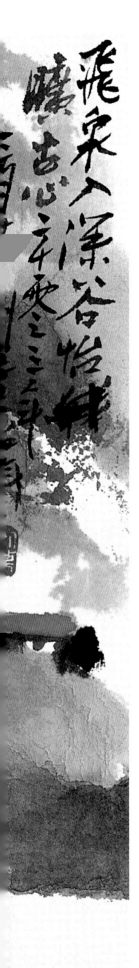

山水
Landscape
27×24cm
2003

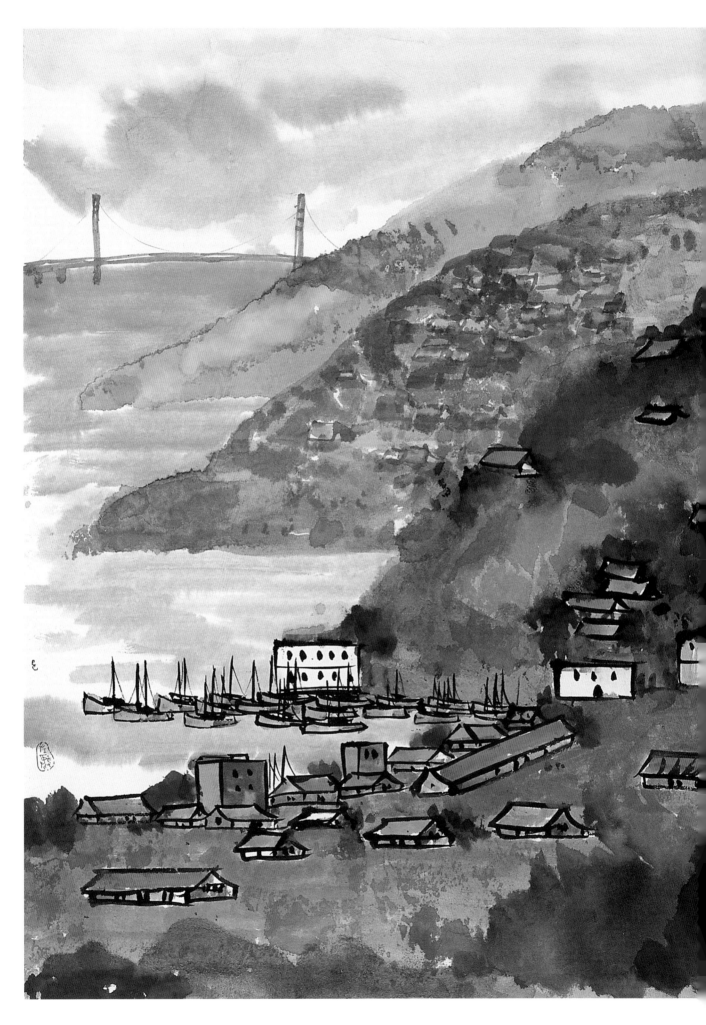

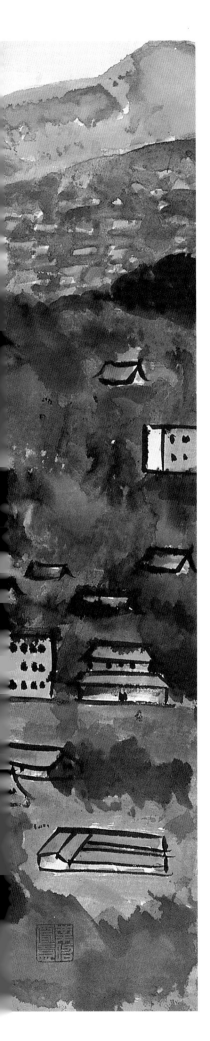

山水 堤波隴

Tiburon

67×66cm

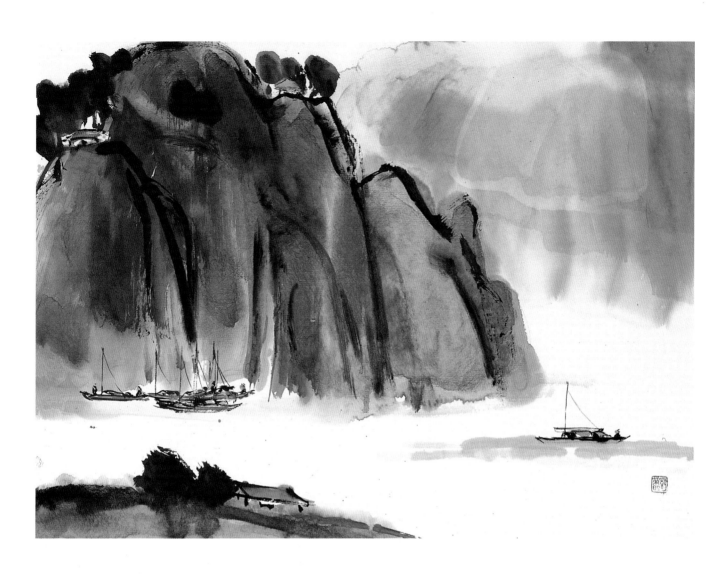

山水 船
Landscape with boats
28×38cm

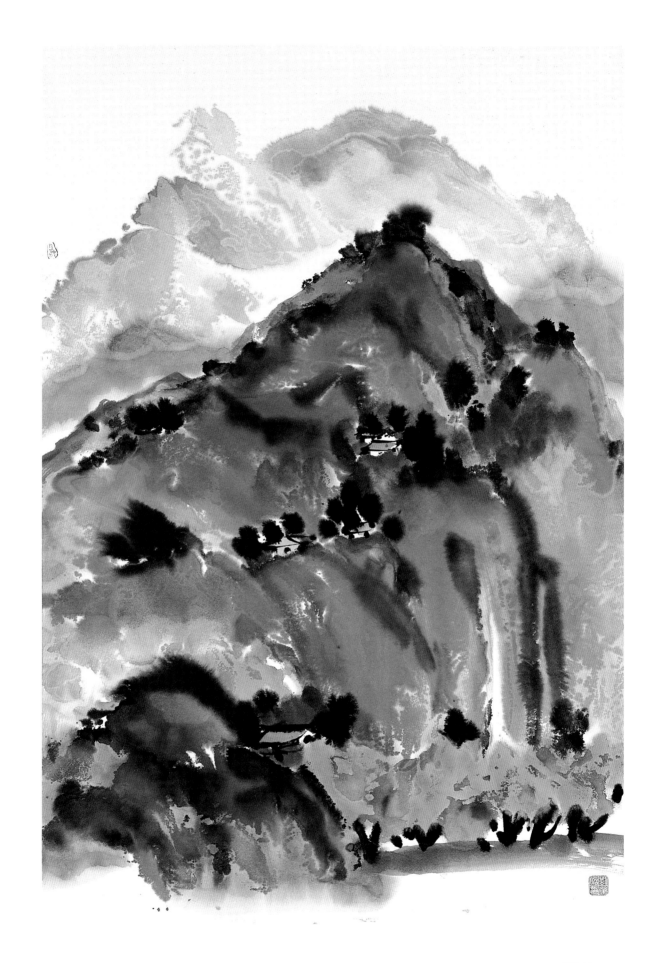

山水
Landscape
102×71cm

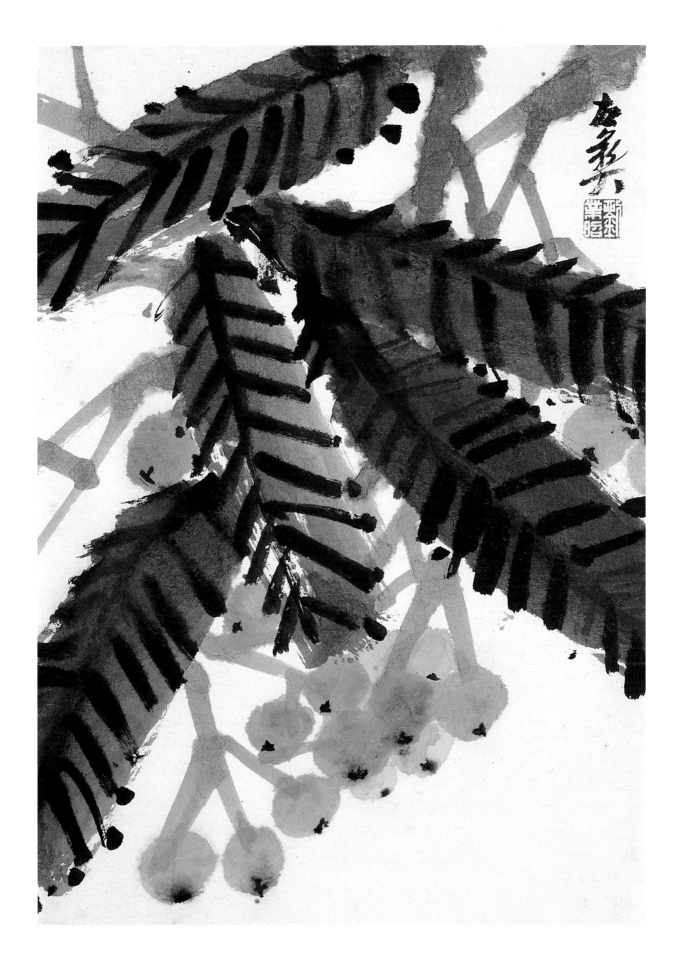

枇杷

Loquat tree with Fruit

42×28cm

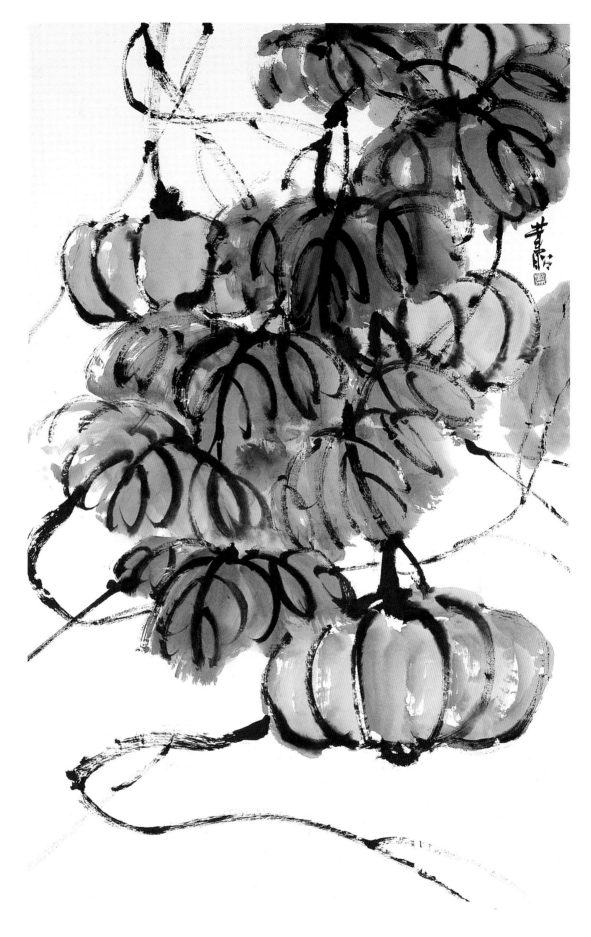

橘色南瓜
Orange Pumpkin
112×72cm

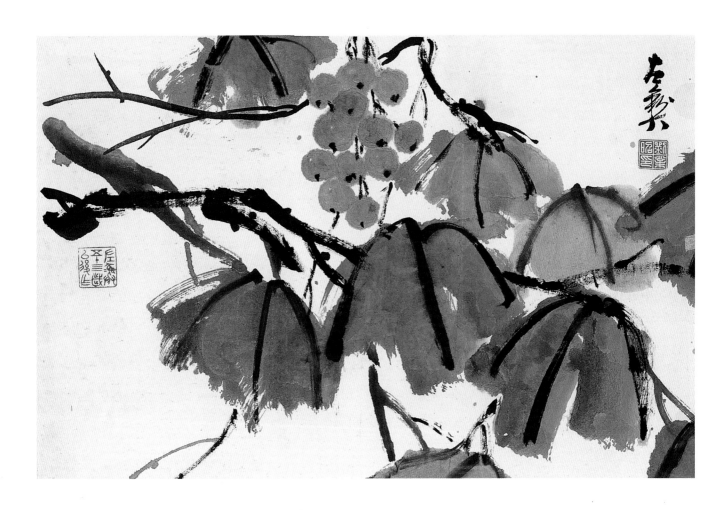

紫葡萄和蟲

Purple Grapes and Bug

34×52cm

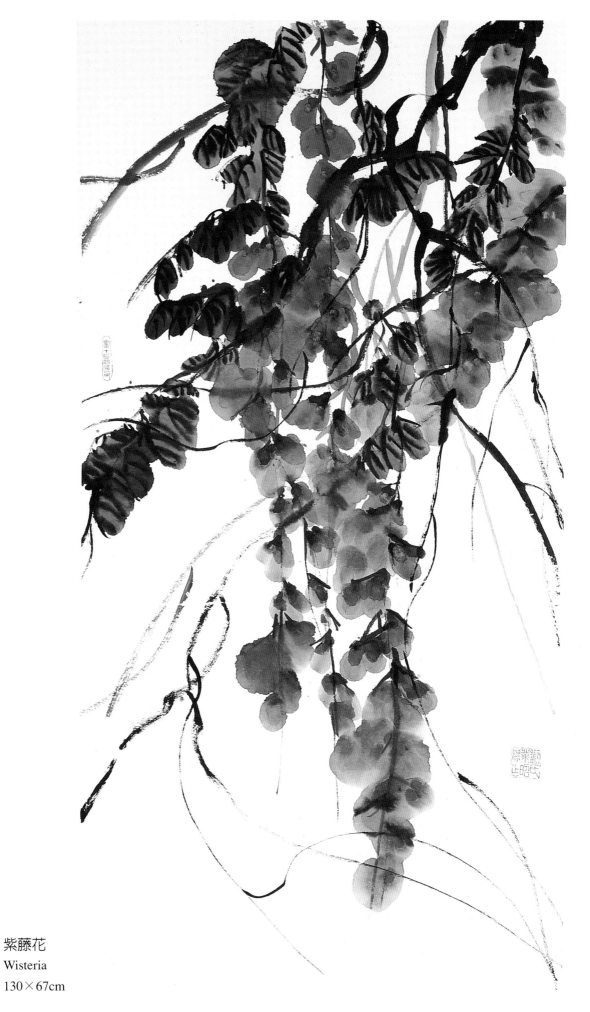

紫藤花
Wisteria
130×67cm

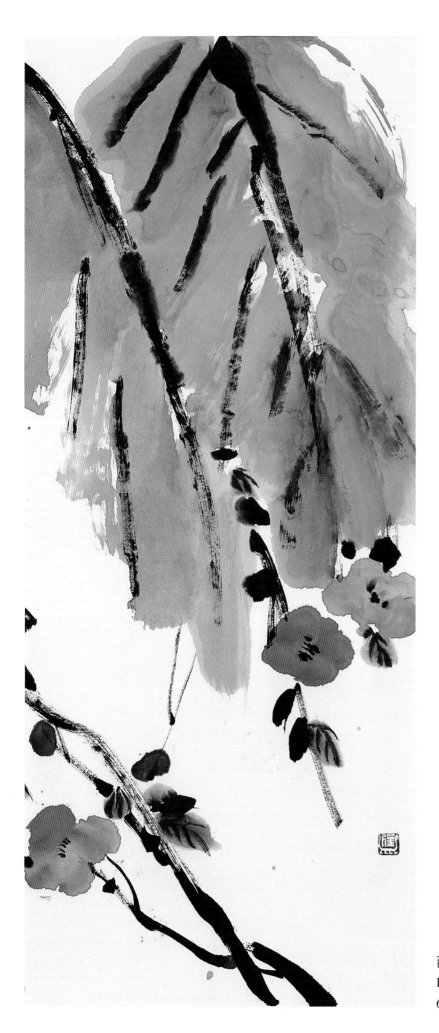

芭蕉葉和花
Banana Leaf and Flower
68×29cm

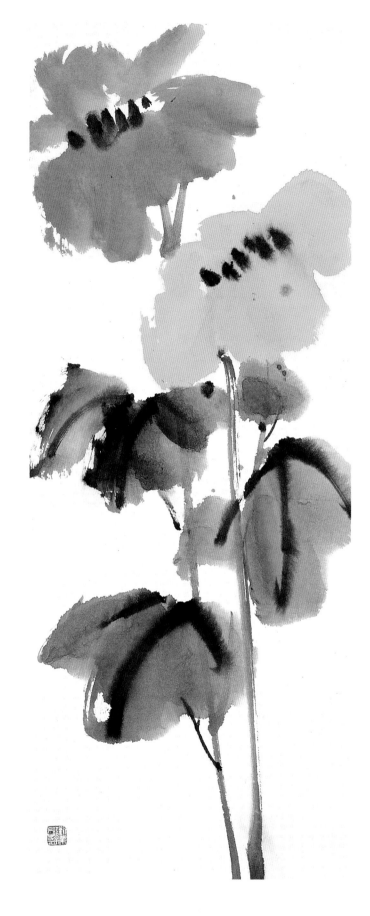

花卉
Flowers on Scroll
61×24cm

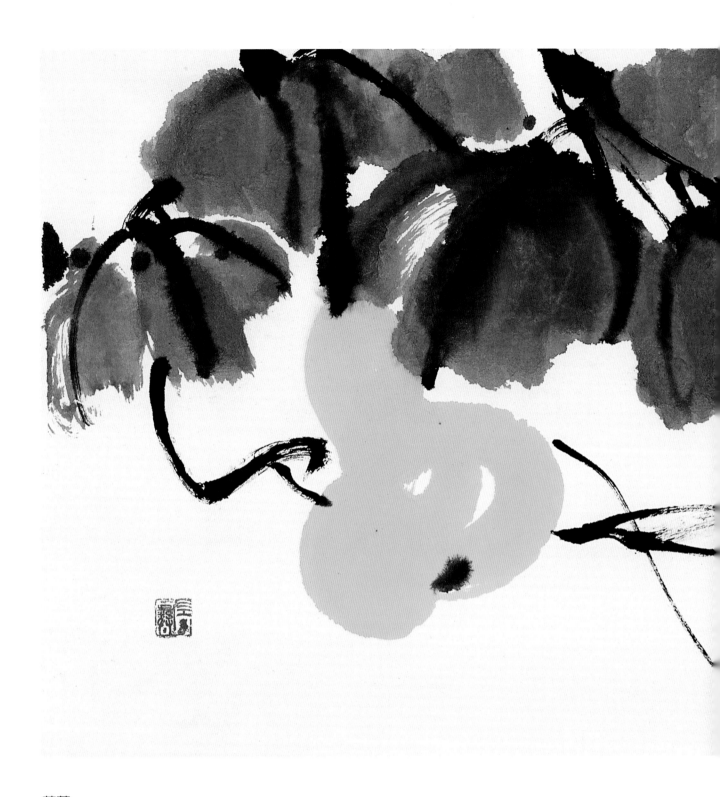

葫蘆
Yellow Gourds
41×86cm

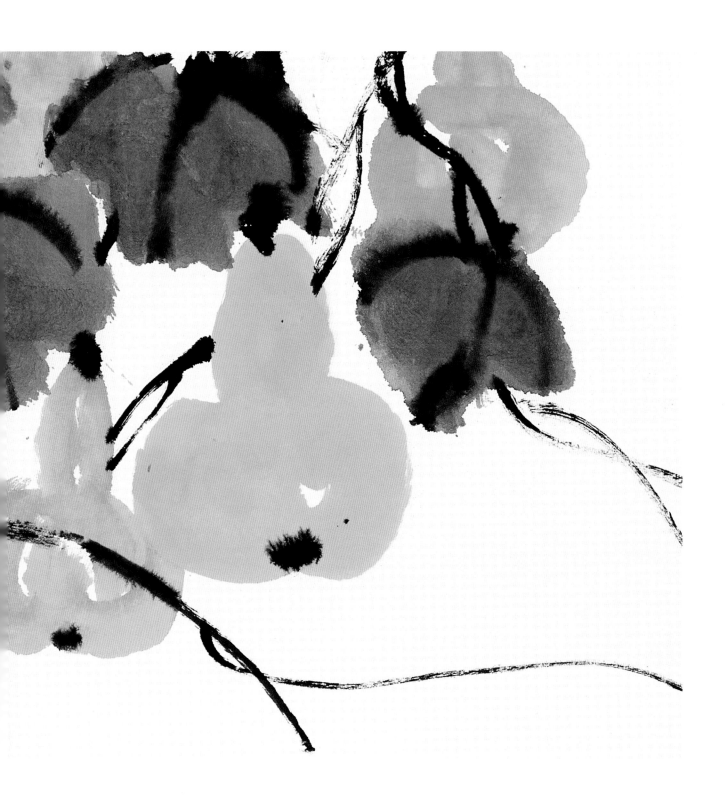

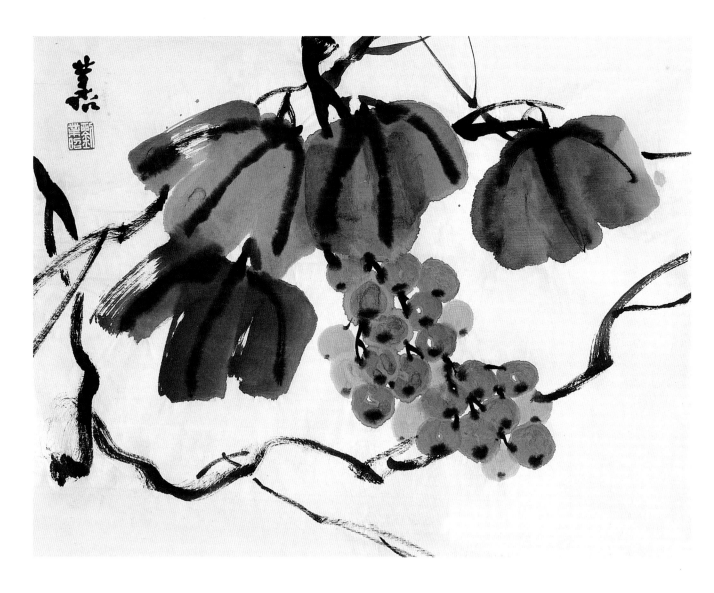

紫葡萄
Grapes
34×44cm

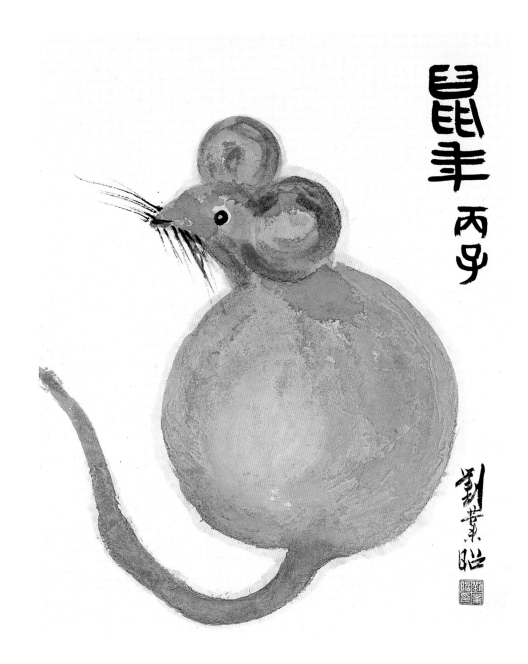

鼠年
Year of the Mouse
54×44cm

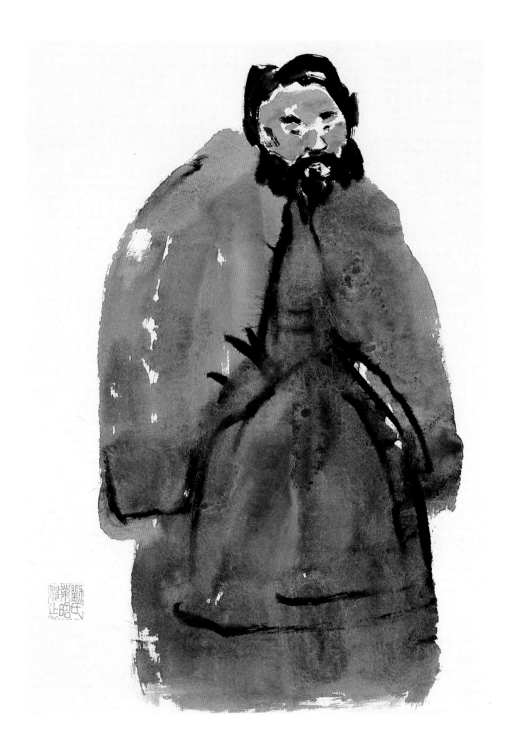

人物
Standing Figure
75×61cm

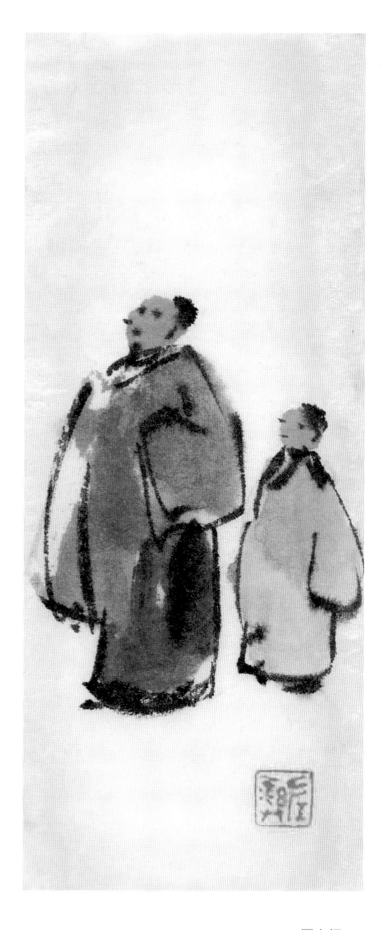

倆人行
Two Figures
20×10cm

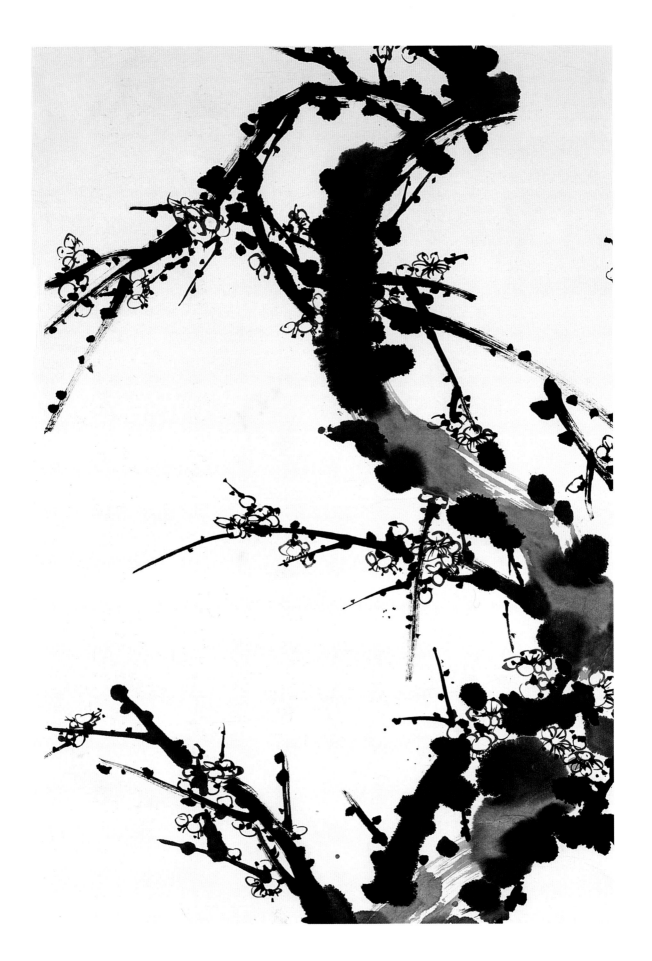

墨梅
Plum Blossom
93×67cm

細草微風岸 危檣獨
夜舟 星垂平野闊 月
湧大江流 名豈文章
著官應老病休 飄飄何
所似天地一沙鷗

唐杜甫詩句 廬嬰

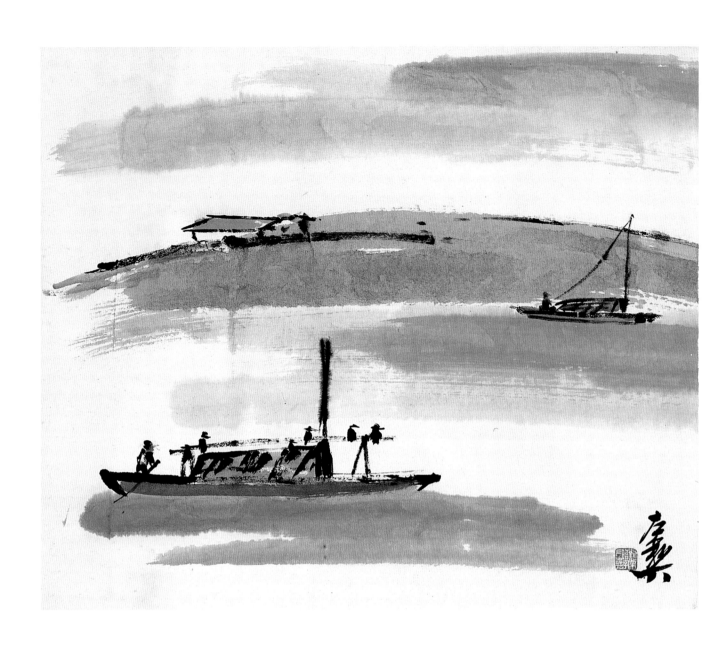

船
Boat
36×44cm

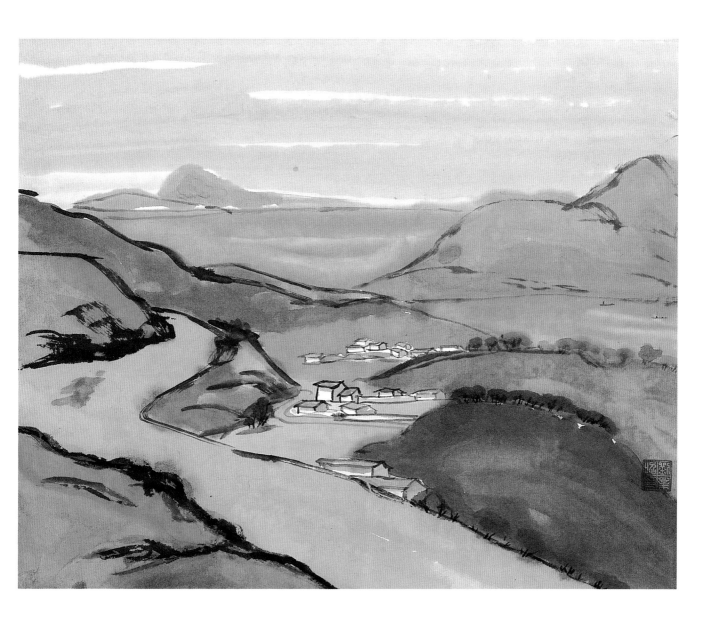

山水
Marin Landscape
41×51cm

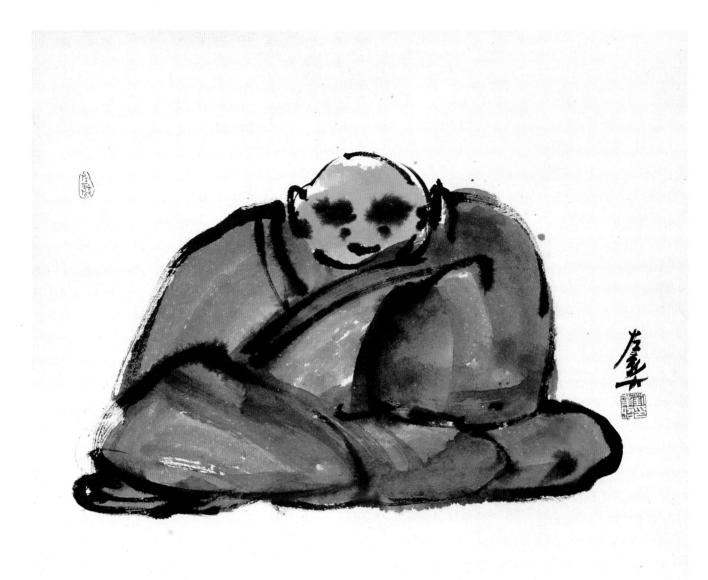

坐著的長者
Reclining Older Figure
39×50cm

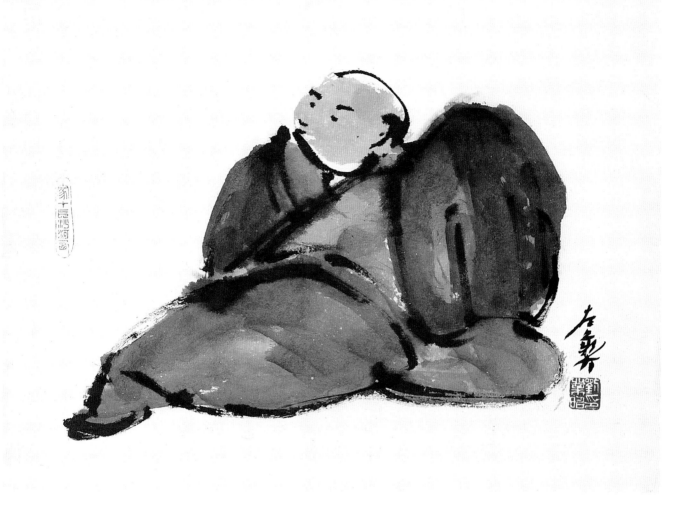

人物
Reclining Young Figure
39×50cm

素描・畫稿
drawings・sketches

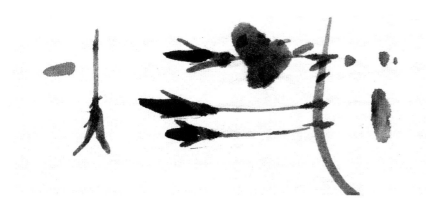

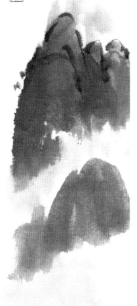

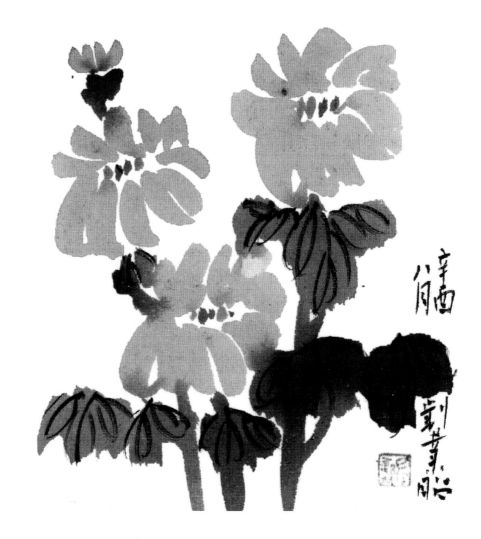

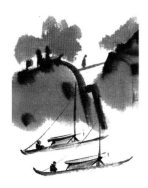

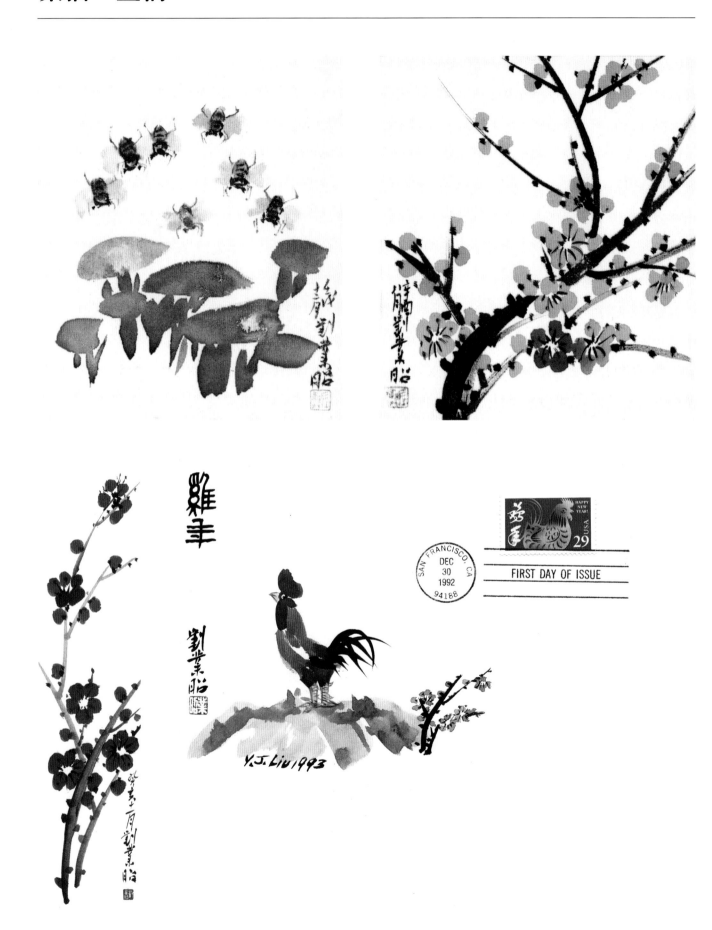

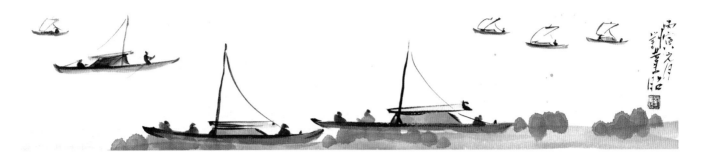

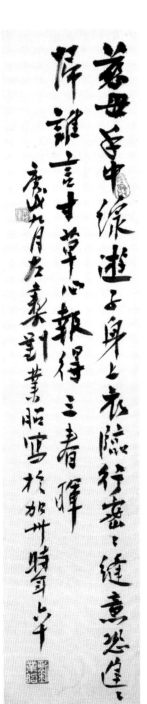

鼠年

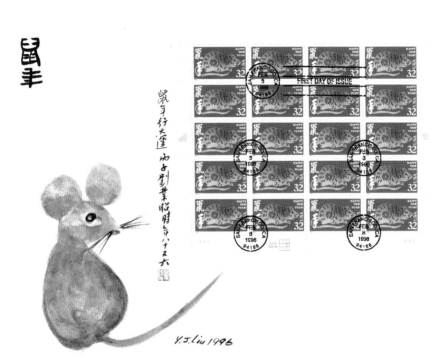

Y.J.Liu 1996

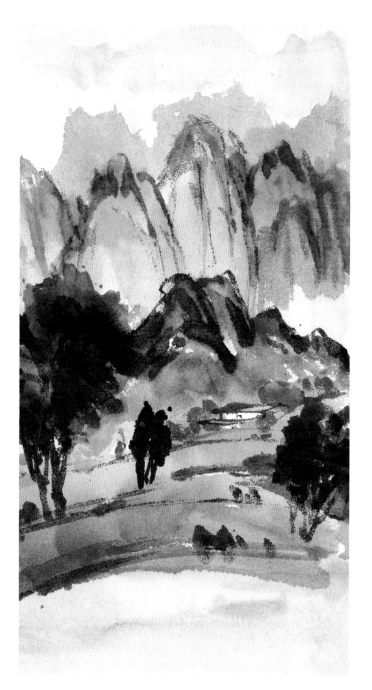

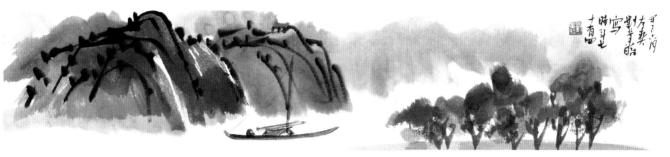

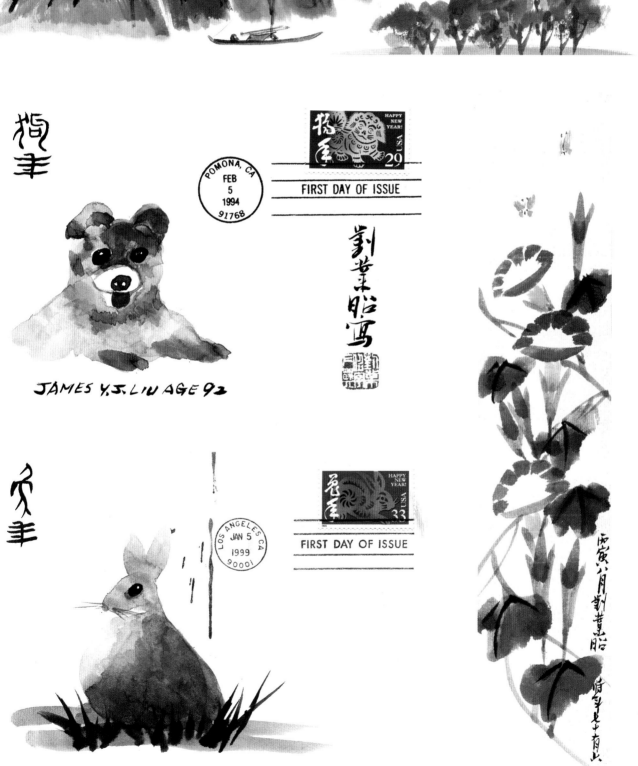

FIRST DAY OF ISSUE

POMONA, CA
FEB
5
1994
91768

JAMES Y.J. LIU AGE 92

LOS ANGELES CA
JAN 5
1999
90001

FIRST DAY OF ISSUE

119

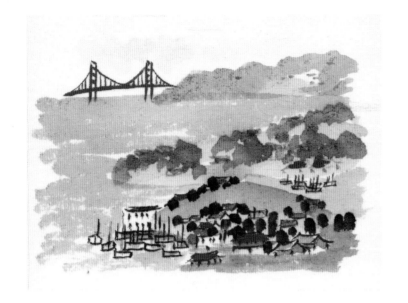

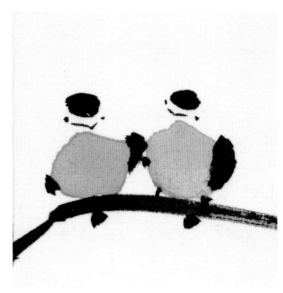

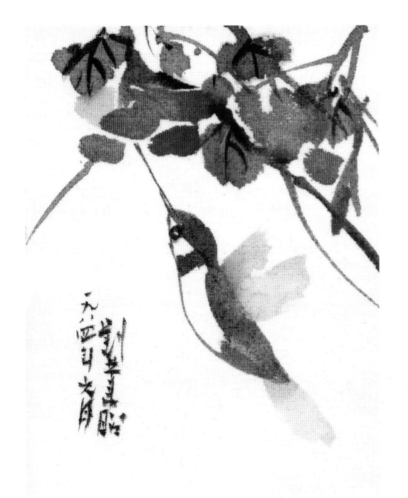

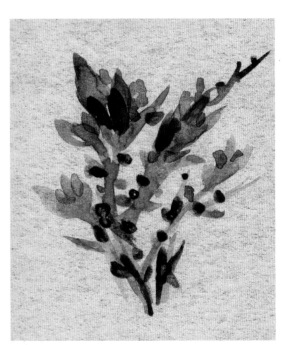

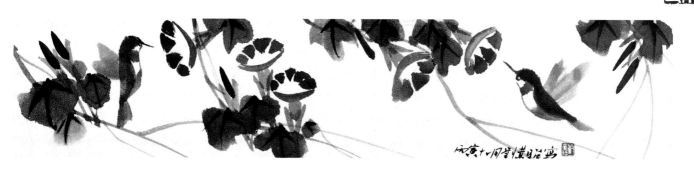

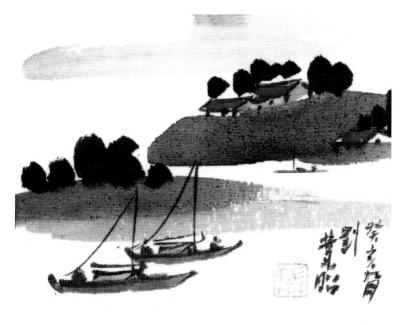

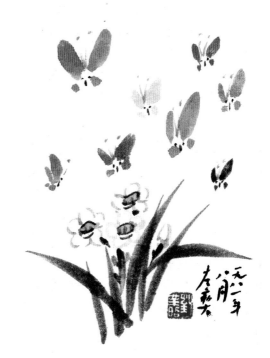

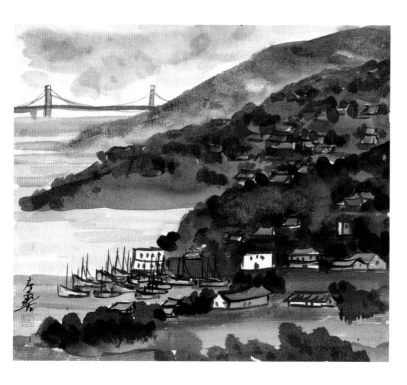

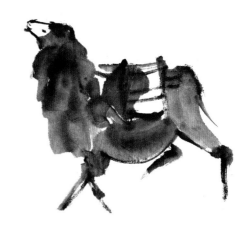

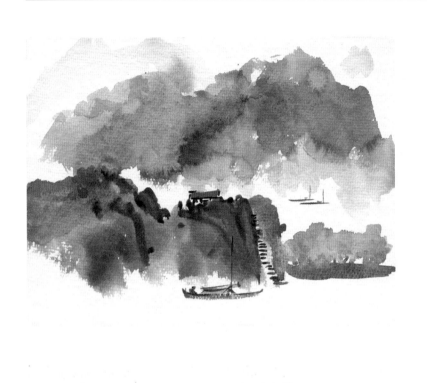

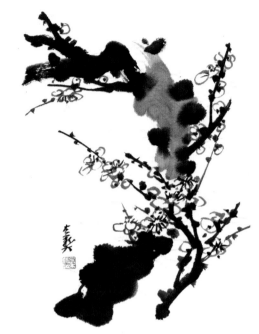

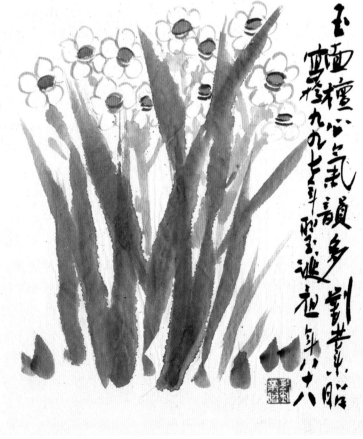

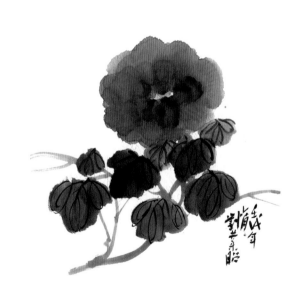

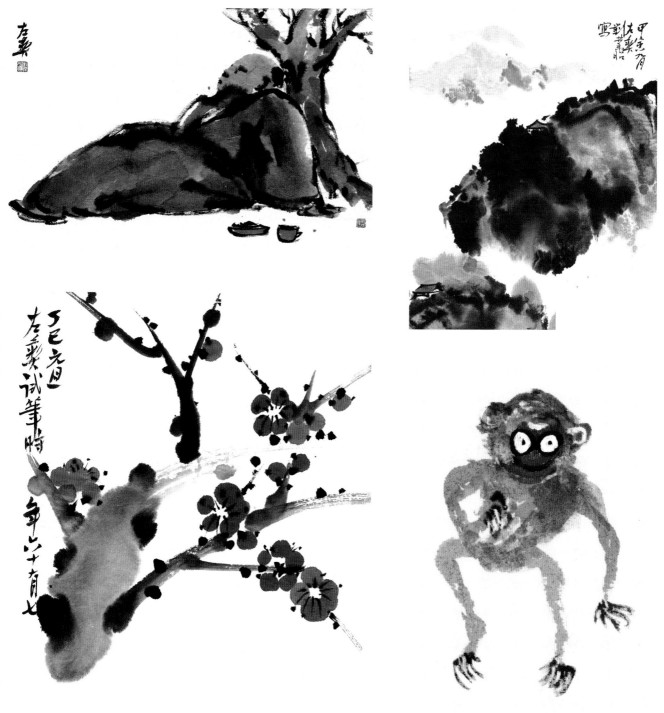

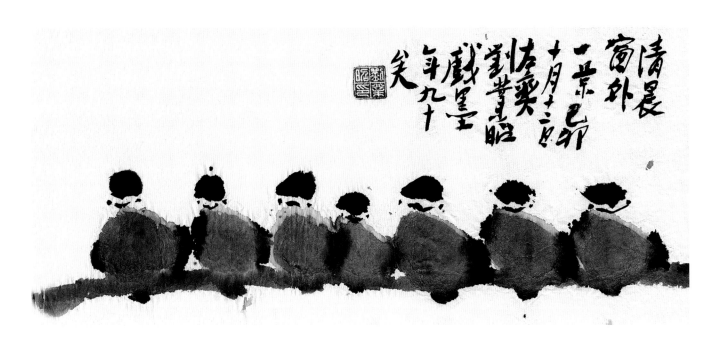

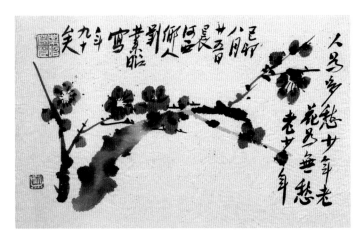

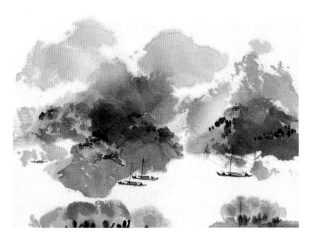

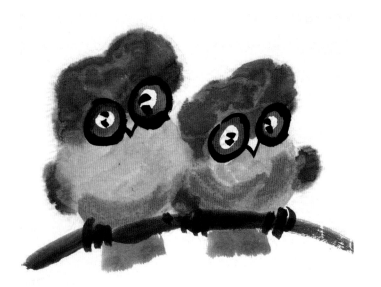

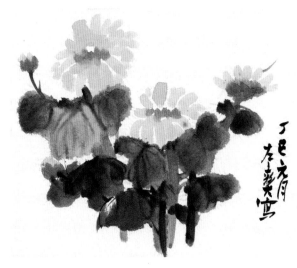

年表
Chronological Biography

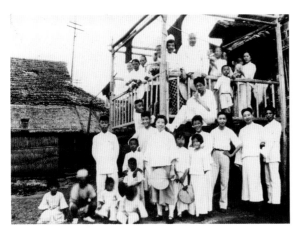

劉業昭(前左一站立者)與父親劉鶚(上中)、長兄劉業
昶(右一)、長姐劉業朝(前中)攝於長沙市平浪宮

1933年攝於杭州

妻李笑金

1945年攝於埃及金字塔前

1910	九月二十三日生於湖南長沙，北門平浪宮，靠山並近於湘江，父親劉鶚，字石薄，為書法名家。
1928	由湖南最好的學校—明德高中畢業，早年喪母，十八歲時喪父，由長兄挑起照顧全家眾多弟妹的重擔。
1930	自小喜愛繪畫，父親去世之後，在大哥、姐姐及二哥的鼓勵及經濟贊助下，進入國立杭州藝專，學習西畫、國畫六年，受教於林風眠、潘天壽先生。
1935	九月十四日與同學李笑金女士結婚，留學日本明治大學，帝國美術學院研究。其同窗蕭傳玖，後來成為名雕刻家，文化大革命時被害。
1937	中日戰爭爆發，回國參加抗戰行列，並接受國民黨政府第一期留日訓練班，八個月的嚴格訓練。結業後被指派為青年團長沙區團部主任，負責湖南全省的團務工作。
1943	接受"中央訓練團黨政高級班"第一期受訓，是全班最年輕的學員。結訓後仍回湖南擔任"三民主義青年團"書記。
1945	抗戰勝利之後，參加"戰後復原考察團"到歐美考察兩年。

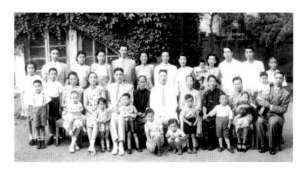

前排右至左，1948年劉業昭(前右一)、妻李笑金(前右二)、長姐劉業朝(前右三)、長兄劉業昶(前右五)、二兄劉業景(前右七)、弟劉業晏(後右六)攝於山東青島

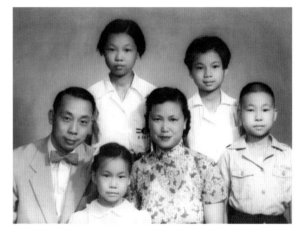

1956年全家福攝於台灣台北

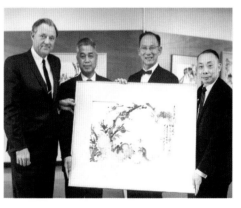

1964年劉業昭(右一)與王昌杰(右二)、鄭月波(右三)、達德博士(Dr. Paul Dodd)合影

1947	由歐美考察歸國，擔任三民主義青年團中央團部第三處副處長，主管文宣和教育。
1948	兄弟姐妹間的親情特別濃厚，在山東青島有第一次的全家大聚會，之後很多親人再沒有見過面。
1949~1960	遷台後奉派為東南長官公署政務委員會文化教育處處長、交通部司長等職，並任教於國立台灣藝專。。
1960	應美國加州舊金山州立大學藝術學院之邀，與鄭月波、王昌杰教授提供作品參展，後受聘為該校中國畫教授
1966	黎錦揚劇作"花鼓歌"在南加州演出時，為其節目表封面作墨梅畫。
1967	由舊金山州立大學退休後，在舊金山北部的名勝地區堤波隴市(Tiburon)設立"寒溪畫室"，為當地"夕陽"扶輪社開辦人之一，熱心推動各種促進中美文化交流的活動。
1972	接受聖地牙哥藝術博物館邀請，舉行隆重之個展，並當眾揮毫示範國畫畫法。博物館並收藏山水畫作一幅。

1966年劉業昭(左一)與花鼓歌演員合影

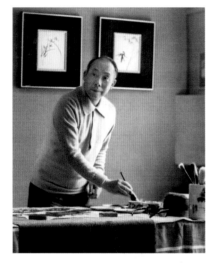

1967年於「寒溪畫室」作畫

劉業昭伉儷

1974　在舊金山漁人碼頭地區另行開設"寒溪畫室",甚受各方人士歡迎及好評。

1978　接受韓國朝鮮日報邀請赴漢城舉行個展妻李笑金去世,結婚四十三年。

1985　回國於國立歷史博物館舉行第一次個展。

1987　當選為舊金山灣區模範父親。

1988　當選為堤波隴市和百維笛市(Belvedere)的"榮譽公民",為華裔爭光。

1992　被推崇為五位影響加州藝術界的藝術家之一回國於國立歷史博物館舉行"八十回顧展"。

1996　於日本神戶舉行個展。

1997　慶祝"寒溪畫室"成立卅週年。

2000　於舊金山州立大學潘朵姬教授所著"開風氣之先(Leading the Way: Asian American Artists of the Older Generation)"書中,被推介為老一輩的在美傑出亞裔畫家之一。舊金山中華藝術學會頒發榮譽獎狀,確認在繪畫藝術上的傑出成就。

2001 接受華府"美國之音"中文部門之專
訪，訪談內容於台灣與中國大陸均有播
出當選為堤波隴市第一屆"桂冠畫家
（特殊藝術家）"五十一年不見的弟弟由
河南鄭州來美看望。

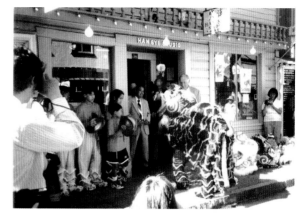

1997年「寒溪畫室」成立三十週年慶，馬林郡
中國社團的舞獅隊特來祝賀。

2002 九十二高齡仍然天天作畫，並且自己裝
裱。

2001年當選堤波隴市第
一屆《桂冠畫家》
(Artist Laureate)

2003 七月在馬林郡四位兒女、六位孫兒女的
陪侍下去世，享年九十三歲設立"寒溪
畫室"共計卅五年，門前一直懸掛中華
民國國旗，足見其身在海外、心在祖國
的心志。

2002年在舊金山扶輪社揮毫

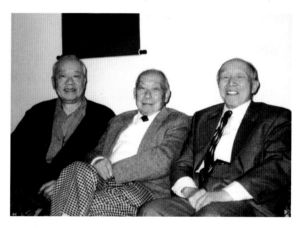

2001年弟劉業晏(右)，劉業昭(中)、劉業昂(左)，闊
別五十一年在美相會。

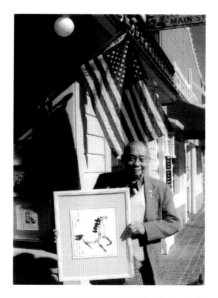

2002年攝於懸掛國旗的「寒溪畫
室」前。

附錄
Appendix

BY SAM WHITING

The Art of Living

At 93, Jimmy Liu still paints every day

Chinese brush painter James Y.J. "Jimmy" Liu has run Hansyi Studio on Main Street in Tiburon for 34 years. That's long enough for one career, but Liu didn't open up until he already had retired from two others.

"To me, I am not important," he apologizes. Then he belies it with his own history — as a Japanese-educated artist who became a colonel in the Chinese army during World War II. An official with both the Nationalist Party and the Department of Culture, he fled Hunan when the Communists took over in 1949. That started an odyssey through Taiwan that led to his becoming an art professor in San Francisco and the town artist laureate of Tiburon.

Liu is the senior shopkeeper on the tourist strip. To call his storefront an art gallery doesn't do it justice. That implies an inviting space with minimal clutter and special lighting. Liu's showroom looks more like the garage of an eccentric who can't bear to throw anything out. There is artwork everywhere, on the walls and stacked up.

A visitor comes through the door, across from Sam's Anchor Cafe, and has to move piles of paper just to find a place to sit and coax conversation spiced by Liu's thick Hunan accent.

ON AGE.

I was born in 1910. I should be 93 years old.

ON SEEING THE WEST.

At the end of the war, I was chosen to tour Europe and the United States on a diplomatic mission. They wanted to learn how to re-build our country — the Republic of China. We stayed one year. I took an American Army boat across the ocean to stop in New York. I wanted to stay, but the general called me home to do a very important job.

ON HIS FIRST RETIREMENT.

In Taiwan I worked for the government for 10 years. But my idea was I wanted to paint because I studied art for six years. So I retired to go back to my art. After that, San Francisco State wanted me to come and teach.

ON HIS SECOND RETIREMENT.

I liked that job, but at 65 you

have to retire. So they make a lunch-party goodbye for me. They ask me, "Where will you go?" I said, "Maybe my painting will take care of that." They say "No, no, no. You open your own studio." I say, "Where?" They say, "We have a place." I say, "I don't know how to do." They say, "We will help you." I say, "Oooh."

ON CROSSING THE BAY.

I never heard of Tiburon before. I came and said, "That's a nice place. I'd like to stay here." I've been here 34 years.

ON LANDLORD RELATIONS.

I signed a contract with him for 20 years. I made it 19 years. He really liked me. He said, "The professor signed a contract with me for 20 years. He already make it. I hope he can stay another 20 years." So I signed it. If I make it, I will be 105 years old. No problem.

ON HIS WALL MAP WITH PUSHPINS IN IT.

People from all over the whole world have my work. They just walk in here from Australia, Mexico, South America, everywhere. Even Moscow. Some Russians bought my paintings, so I put the pin there.

ON HIS STUDIO.

I don't do painting here. At my home I have a big studio to paint. I rent a big place with a view. I get up at sunrise and paint early in the morning. If I start, I can't stop.

ON STUDIO HOURS.

I'm open seven days a week, 11-6. I have to make a living. I have no money. I have money, I spend money. Rent is expensive, so I have to sell a painting every day.

ON HOBBIES.

I like the basketball — Lakers. In college, I played basketball. I'm a very good shooter. I'm 5'6" (he says reading his driver's license). Now I'm shorter. Here they say, "You're so short. How do you do it?" I say, "In China, everybody [is] short."

ON OUTINGS.

San Francisco, once a week by ferry, on Mondays. Very good. I have Chinese food, see friends. Just for a few hours.

ON HERITAGE.

My daughter, Diana Liu is an artist, too. She lives in Marin County and is a designer. I call her every day.

ON RETIRING FOR THE THIRD TIME.

I paint every day. My last day is when I'm dead. That's when I retire. ◆

E-mail Sam Whiting at swhiting @ sfchronicle.com.

PHOTOGRAPH BY JERRY TELFER

JAMES YEH-JAU LIU
(born 1910)

James Liu can be found most days in his studio on Main Street in Tiburon, California. His Han Syi Studio has been a fixture in this charming bay-side community for over 30 years.

Liu, who is called "Jimmy" by close friends and "Professor" by others, was born in Changsha, Hunan, China in 1910. His art studies began when he learned the fine art of calligraphy from his father, an artist of note. Liu went on to the National Academy of Fine Arts in Hangchow from which he graduated in 1935. There he studied both Chinese brush painting and Western style drawing from his French trained teachers. This ended when Japan attacked China in 1937 and Liu was drafted into the Chinese National Army where he served under Chiang Kai-shek. At the end of World War II, Liu was sent by Chiang Kai-shek with selected others on a world tour of the outside to learn about the West. They were the first permitted to "go outside."

In 1949, Liu left mainland China for Taiwan where he served as the Director of Communications and Transportation and taught classes at the Taiwan National Academy of Art. In 1962, Liu decided to move and settled permanently in the United States. Once here, he was invited to teach Chinese painting by his friend Professor Kai-yu Hsu, at San Francisco State University's Humanities School. And in 1967 he founded his Han Syi Studio where he teaches painting as well as creates his own images.

Liu's images are a fusion of things remembered from China and the north San Francisco Bay locale in Tiburon. He can paint beautiful plum blossoms, landscapes, figures, flowers and birds and then paint the scene around him such as the Golden Gate Bridge from Tiburon or San Francisco's bay and hills. His paintings exhibit his dexterity and skill with the brush as colors are applied to define space and create images giving many people great pleasure.

Professor Liu, at 90 years old, still paints every morning at home before going down to his Han Syi Studio to frame his paintings and greet friends and people visiting from all over the world. He is a familiar, energetic and cheerful figure on Main Street, Tiburon, U.S.A.

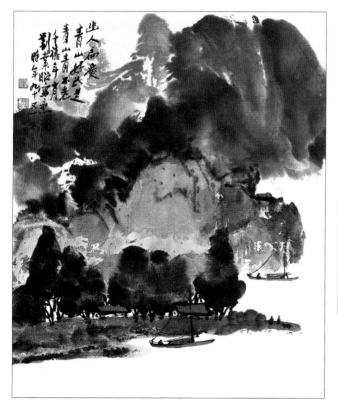

James Yeh-jau Liu
Landscape, 2000
30 x 36"
ink and colors on paper
Collection of the Artist

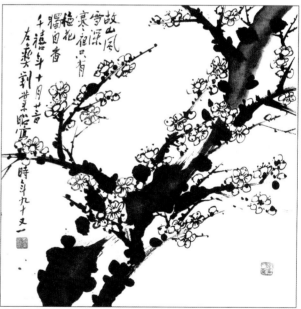

James Yeh-jau Liu
Black and White Plum
Blossom, 2000
ink on paper
31 x 32"
Collection of the Artist

開風氣之先出版 老一輩藝術家薈萃

就成作創的家術藝裔亞期早解了會社流主助有 作新如朵潘者作

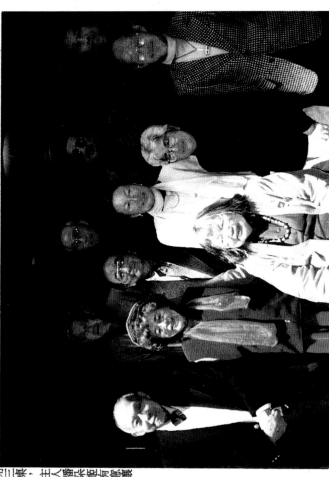

【記者楊芳芷金山報導】最近出版的「開風氣之先：老一輩亞裔藝術家」（Leading The Way: Asian American Artists of The Older Generation），作者潘朵姬（Irene Poon Andersen），三日邀請畫中廿五位受訪的亞裔藝術家餐敘，慶祝這場艱辛的藝術盛宴及新書的順利出版。

書中廿五位亞裔藝術家，其中有十一人已經過世，另有五位居住外埠，未能出席當天在舊金山羊城餐館隱學餐會。

前來與會餐敘的華裔藝術家有劉業紹、黃銀英（Nanying Stella Wong）、黃玉雪（Jade Snow Wong）、羅黃卿義（Charles Wong）及 Benjamen Chinn；日裔藝術家有 Ruth Asawa、George Miyasaki、Arther Okamuru、Kay Sekimachi、原田種之（Taneyuki Dan Harada），以及菲律賓裔的 Carlos Villa。當天席開三桌，主人潘朵姬對號入座，特別安排座位，讓常有機會交換創作心得或話家常的藝術家相識，他們有幾會交換創作心得。

「開風氣之先」這本書介紹了一九三〇至六〇年代亞裔藝術家五十多人，包括日裔、華裔及菲律賓裔藝術家的老中青三代黃國新水彩畫家目前高齡八十五了……

聚餐午加參家術藝裔亞的訪受中書講邀日三受潘朵姬作者書－姬朵潘者作書。前排左起：BenjamenC hinn、Kay Sekimachi、Carlos Villa 之種田原、霓鋃黃、昭業劉排前；起左圖。來前兒不、地零圖雅西或英夏烟香散居裔，世過紀已人五另，席出位一十有中家術藝訪受應五十是、霓烟夏（香坐中）RuthAsawa、Arther Okamura、霍剛黃羅、霓細黃羅；排後：BenjamenC hinn、Kay Sekimachi、之種田原 Carlos Villa，George Miyasaki和 Carlos Villa。
（攝正芳楊記者記）

James Yeh-Jau Liu Exhibition History

One Man Shows

Marysville, California, Arts Council at the City of Marysville	2003
Millbrae, California, Nai Hai Arts Center	2002
San Francisco, Sun Yat-Sen Memorial Hall	2000
Tiburon, California, City of Tiburon Town Hall	2000
San Francisco, California, Gallery On The Rim	1999
San Francisco, California, Gallery On The Rim	1997
Kobe, Japan, Butterfly House Gallery	1996
Marysville, California, City of Marysville, Consecutive Exhibits	1990-1995
Taipei, Taiwan, Taipei City Museum, Celebrative Exhibit	1994
Taipei, Taiwan, National Museum of History, 80 Year Retrospective	1992
Taipei, Taiwan, National Museum of History	1985
Seoul, Korea, Seoul Newspaper Center	1978
San Diego, California, The Fine Arts Gallery of San Diego	1972

Group Shows

San Francisco, Sun Yat-Sen Memorial Hall	2002
"Leading The Way - Asian American Artists of the Older Generation" Exhibition	
Gordon College, Wenham, MA	2000
Millbrae, California, Second Millennium Art Exhibition,	
The Chinese Arts Association	2000
Millbrae, California, Artists From Three Locals,	
The Chinese Arts Association	1999
Tiburon, California, Five Artists Who Influenced Art in California,	
Catherine Coffin Phillips Library	1998 (Ongoing)
Salt Lake City, Utah, Pacific Rim Exhibition, City of Salt Lake	1997
Millbrae, California, Group Exhibition of Ten Distinguished Chinese	
Artists, Taipei Economic and Cultural Office	1996
Carmel, California, Three Artist Show, Lakey Gallery	1963
San Francisco, California, Three Artists From Taiwan,	
San Francisco State College	1962

Permanent Collections

The Galtes Museum of the University of San Clara, Santa Clara, California
The Fine Arts Gallery of San Diego, San Diego, California
The Catherine Coffin Phillips Library, Tiburon, California
The National History Museum, Taipei, Taiwan, Republic of China
Ministry of Education, Taipei, Taiwan, Republic of China
National Taiwan Arts Center, Taipei, Taiwan, Republic of China
National Modern Arts Museum, Seoul, Korea
The World Journal, Millbrae, California
City of Marysville, Marysville, California
Angel Island Heritage Institute, Tiburon, California

國家圖書館出版品預行編目資料

劉業昭書畫紀念展 = A Memorial Exhibition of Liu
Yeh-jau's Art / 國立歷史博物館編輯委員會編輯
-- 臺北市 ： 史博館, 民94
面； 公分

ISBN 986-00-0454-4(平裝)

1.書畫 – 作品集

941.5 94002970

劉業昭書畫紀念展
A Memorial Exhibition of Liu Yeh-jau's Art

發 行 人	黃永川	Published by	Huang Yuan-chung
出 版 者	國立歷史博物館		The National Museum of History
	台北市南海路四十九號		49, Nan Hai Road, Taipei, R.O.C.
	電話:886-2-23610270		TEL:886-2-23610270
	傳真:886-2-23610171		FAX:886-2-23610171
著 作 人	劉業昭	Copyright Owner	Liu Yeh Jau
編 輯	國立歷史博物館編輯委員會	Editor	Editorial Committee
主 編	戈思明	Chief Editor	Ge Sz- ming
執行編務	鄒力耕	Executive Editor	Tsou Li-keng
編輯顧問	劉興珧	Consultant	Diana Liu
英文翻譯	周妙齡 黃美珠	Translator	Chou Miao-ling Huang Mei-chu
英文審稿	Mark Rawson	Reviser	Mark Rawson
展場設計	郭長江	Designer	Huo Chang -chiang
攝 影	卞貝內	Photographer	Ben Benet
印 刷	士鳳藝術設計印刷有限公司	Printer	Show-printing Art Company
出版日期	中華民國九十四年三月	First Published	March 2005
定 價	新台幣550元	price	NT$550
展 售 處	國立歷史博物館文化服務處		
	地址：臺北市南海路49號		
	電話：02-23610270		
統一編號	1009400032	GPN	1009400032
ISBN	986-00-0454-4 (平裝)	ISBN	986-00-0454-4